How To Photograph

Flowers

How To

Photograph

Flowers

Heather Angel

STACKPOLE
BOOKS

Published by
STACKPOLE BOOKS
5067 Ritter Road
Mechanicsburg PA 17055

Printed in China

First Edition

10 9 8 7 6 5 4 3 2 1

Cover design by Wendy Reynolds

Cover photo: coreopsis daisies, red phlox, and bluebonnets near
Cuero, Texas, April.

Photo, page vi: Colorado columbine *(Aquilegia coerulea)*, Yankee Boy
Basin, Colorado, July.

Library of Congress Cataloging-in-Publication Data

Angel, Heather
 How to photograph flowers / Heather Angel.
 p. cm.
 Includes bibliographical references (p.)
 ISBN 0-8117-2455-7 (pbk.)
 1. Photography of plants. 2. Flowers—Pictorial works.
I. Title.
TR724.A533 1997
778.9'34—dc21 97-22370
 CIP

CONTENTS

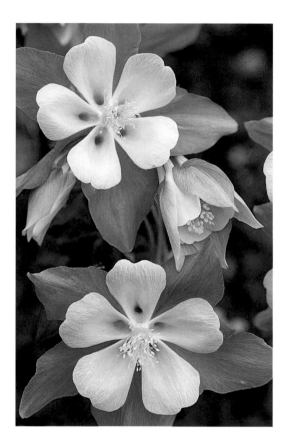

ACKNOWLEDGMENTS

It would be hard to imagine a more idyllic way to earn a livelihood than traveling around the world in search of flowers to photograph. However, many of the pictures reproduced in this book were achieved only after much preparation and planning. To all the people who assisted me in my travels, answered my queries, and provided technical information, as well as the companies that lent me equipment, I extend my grateful thanks. In particular, I should like to thank the British Council, Delhi; Dr. A. D. Duhon; Hasselblad (UK) Limited; Huntingdon Botanic Garden; Joseph Van Os Photo Safaris; Kodak Limited; Carol Leigh; Nikon UK Limited; Los Pinos Centro de Fotografia; Occidor Adventure Tours Limited; Polaroid UK Limited; The Royal Botanic Gardens, Kew; Workshops in the West; and Zegrahm Expeditions.

I especially wish to thank Colour Processing Laboratories for their efficient yet careful film-processing service; Valerie West for converting my handwritten script into an immaculate manuscript; and Lindsay Bamford, my photo librarian, for helping me select the final images. My husband, Martin Angel, has—as always—encouraged me throughout and assisted me on some of my overseas trips. Mark Allison at Stackpole Books never failed to respond to my faxed queries, and he has been a great enthusiast of the whole project throughout. Jon Rounds at Stackpole was also tremendously helpful during the production stages.

INTRODUCTION

One of the benefits of living in a temperate latitude is that after a long winter without a flower in the landscape, we appreciate the first blooms of spring all the more. As the buds burst, our spirits are uplifted, and we become eager to achieve even better pictures than last year.

Though it's necessary to know how to use and get the best out of one's equipment, this has always been the least appealing aspect of photography to me. Traveling and trekking to remote locations to feast my eyes on natural gardens is infinitely more exciting. Even so, my equipment must be reliable, with clean optics. This is secondary to having a seeing eye, however. The ability to extract memorable pictures is, no doubt, instinctive for those with an artistic eye, but I believe that with practice, it is a skill anyone can develop over time. The great bonus of photographing flowers is that regardless of the price tag on the camera, anyone can participate. Since flowers are ephemeral, you need to be in the right place at the right time, and luck plays no small part in getting good photographs.

It is evident from the people I meet on my workshops how much pleasure many gain from photographing flowers, be it in their own backyard or a remote wilderness area. Nowadays, travel to far-flung locations has brought previously inaccessible native floras within reach of more than a handful of academic botanists. In addition to photographing flowers extensively on both sides of the Atlantic, I have been fortunate to work in locations as diverse as South Africa, China, the Galápagos Islands, the high Arctic, the Mediterranean, and the Himalayas, and to participate in an unforgettable pony trek to Kashmir.

Photographing garden flowers may not involve such intrepid expeditions, but it can be equally challenging and rewarding nonetheless. In fact, the current vogue for wildflower gardens has blurred the traditional distinctions between garden flowers and wildflowers. While the majority of illustrations in this book are of wildflowers, a few cultivated flowers have been included, as well as tree flowers and some fruits, since they expand the range and season of readily available photographic subjects.

To make for easier reading, only common names of flowers have been used in the text. Scientific names, such as *Rhododendron arboreum,* which are universally recognized, are included in the captions. (In referring to photographs taken in New Zealand, I use the regional spelling "lupins," rather than "lupines," as it is spelled in the United States.)

However arresting a photograph may be, once I have savored the image, I am eager

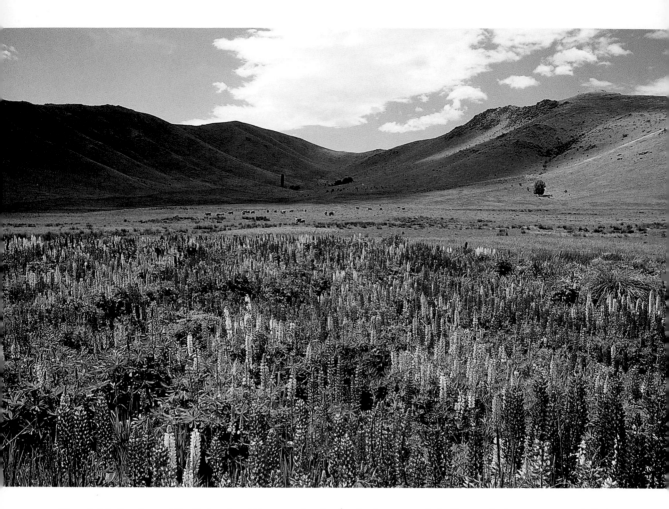

Roadside lupins with distant cattle, north of Twizel, South Island, New Zealand, November. *Nikon F4, 20–35mm AF f/2.8D Nikkor lens, Ektachrome 100 Plus.*

Like the Texas bluebonnets (also a lupine), Russell lupins enliven the roadsides around New Zealand's Lake Tekapo in the spring.

to learn more. Indeed, if there is only a scanty caption or, worse still, no caption at all, I feel cheated. While I welcome the identification of the plant and when and where it was photographed, I feel that the precise exposure, such as 1/125 of a second at f/8, is immaterial. One of the most satisfying aspects of photography is to experiment for yourself—be creative—not just slavishly mimic the framing and exposure used by someone else.

On the other hand, for more than two decades, through my lectures and writing, I have always been happy to share many tips and hints for gaining more satisfying results when photographing the natural world, explaining why I chose to use a particular filter, a reflector, a diffuser, flash, or a long exposure to achieve the result I desired.

In this practical how-to book on field techniques for flower photography, some pictures have come from my existing stock

photo library, but most were specifically taken for this volume. The locations span a variety of habitats—meadows, mountains, forests, deserts, and wetlands. Within the captions, I have attempted to blend natural history with photographic techniques.

Whether you are a beginner with fairly basic equipment and limited techniques or an experienced photographer who is constantly experimenting, the most important factor is that you have fun. We all experience frustration at times when we fail to locate a particular plant, the wind refuses to abate, or a bud we had been waiting for days to open becomes a slug's feast overnight, but all this pales at the times when our goals are far exceeded.

My quest in search of photogenic flowers has led me along many voyages of discovery. I shall forever be grateful to my maternal grandmother, who fired my enthusiasm for looking at wildflowers during the long summer holidays I spent on her Suffolk farm, although it was many years later that I took up photography. As I look back at the more than three thousand different kinds of flowers I have captured on film, I can relive past trips and look forward with eager anticipation to many new delights in the years ahead.

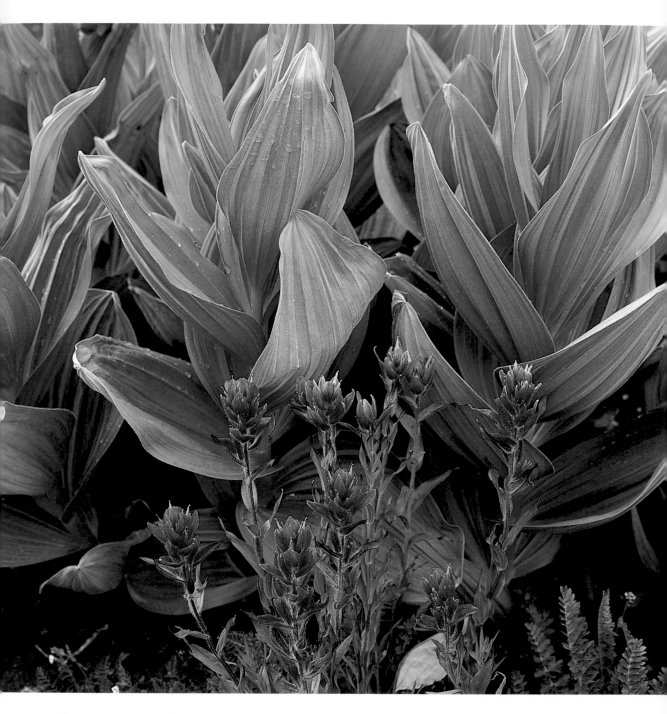

Rosy paintbrush *(Castilleja rhexifolia)* backed by leaves of cornhusk lily *(Veratrum tenuipetalum)*. Yankee Boy Basin, Colorado, July. *Hasselblad 500 C/M, 150mm f/4 Sonnar lens, Ektachrome 100S.*

Flower Photography— a Science or an Art?

What better way to spend a spring or summer day than out on location in search of worthy flowers to photograph? Beautiful, colorful, delicate, exquisite, pretty, and spectacular are just a few adjectives that could be used to describe most flowers, although potent would be more applicable to carrion flowers, which produce a noxious smell of rotting flesh to attract their pollinators. Beauty is in the eye of the beholder, however, so what repels one person may appeal to another.

Flowers are very diverse in form and size, ranging from some so small they have to be photographed larger than life-size to the giant, 6-foot-tall titan arum (see page 73). Thus there is no single approach to flower

Scarlet gilia *(Gilia aggregata)* with blue penstemon near Togwotee Pass (9,658 feet), Teton Wilderness Area, Wyoming, July. *Nikon F4, 105mm AF f/2.8 Micro-Nikkor lens, Ektachrome Lumière 100.*

Rich rewards often arise as a result of taking random paths. A small track branching off a busy road led to an old dump site, flanked on one side by a bank covered by a glorious mix of red and blue blooms. My decision to return early the next morning was rewarded by a lower-angled sun backlighting the flowers and a fleeting visit from a hummingbird feeding on the scarlet gilia.

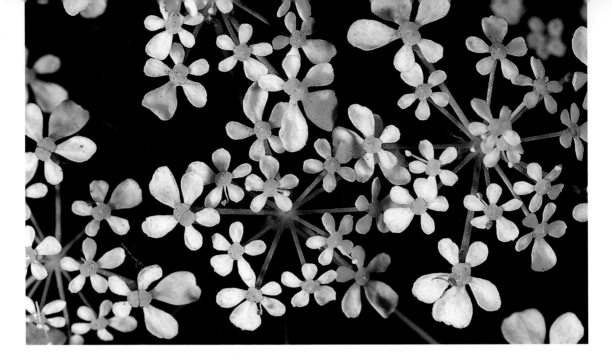

Detail of Queen Anne's lace *(Anthriscus sylvestris)* flowers, Surrey, England, May. *Nikkormat FTN, 105mm f/3.5 Micro-Nikkor lens, with close-up lens, Kodachrome 25.*

Queen Anne's lace is a widespread plant of lanes and byways, and I tended to pass it over; after all, the flowers of this humble umbel are not particularly colorful or striking. One day, however, armed with a macro lens, I discovered the exquisite shapes of the individual florets within the overall design. When small flowers are photographed at larger than life-size so that their structure becomes apparent, they are no longer insignificant as they become a delight to the eye.

photography. Within this book I outline many techniques and suggest ways they may be applied. The choice is yours, but often this will be dictated by the subject, the situation, or the lighting conditions that prevail at the time. Rather than adopt a stereotyped "safe" approach, try to explore various possibilities. Set yourself a challenge, and use your eyes as well as your mind.

Evolution of Flower Photography

Since the dawn of photography, flowers have captivated photographers the world over. The diversity of their color, shape, and size lends itself to a wide-ranging scope of photographic approaches, from colorful landscapes and close-up studies to abstract art forms. There are few places in the world where, at the right season, flowers cannot be found. While a single species may bloom for only a limited time, it is but one in the natural succession of flowers that appear over a period of several weeks or, if weather conditions are favorable, several months. The flower photographer's season can be extended still further by traveling to different latitudes. By the time blossoms have faded and fruits have developed in the Northern Hemisphere autumn, buds are beginning to break in the Southern Hemisphere spring.

Even without a camera, flowers can be used to make memorable images. William Henry Fox Talbot (1800–77) used flowers for some of his photogenic drawings or sunprints. After making his own photosensitive paper, he placed various objects, including flowers, on top of it and exposed it to the

Marsh marigolds *(Caltha palustris)* in a wet meadow near Maentwrog, Wales, April. *Hasselblad 500 C/M, 60mm f/3.5 Distagon lens, Ektachrome 64.*

I was driving around the country lanes looking for pictures to complete a solo exhibition of my work to be staged in Wales. The backlit wet meadow seemed to have possibilities, and even though the sky was not very colorful, the yellow flowers and fresh green leaves encapsulated a spring scene. In the end, this picture was used on the cover of the exhibition catalog. I like the way the band of darker green reeds suggests a river flowing through the scene.

sun. This resulted in white negative life-size images against a darker background.

Talbot's friend and colleague, Sir John Herschel (1792–1871), invented the cyanotype, or blueprint, process in 1842, and not long afterward Anna Atkins (1799–1871) used it to

A cyanotype (blueprint) of a lady's mantle *(Alchemilla mollis)* flower collected from my garden, copied onto slide film for reproduction here.

The cyanotype process produces a white negative image against a Prussian blue background. The branching pattern of the flower head, the shape and position of the bracts (small leaflike structures that arise from a stem beneath the flowers), and the structure of the tiny flowers are all clearly discernible, more so than in a straight photograph of the living plant.

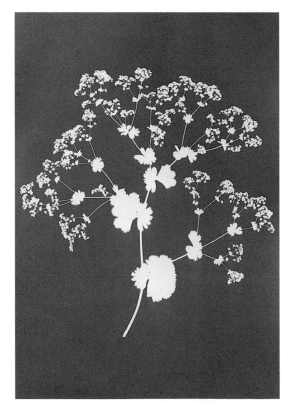

portray a prodigious number of botanical specimens. In this process, a mixture of ammonium ferric citrate and potassium ferricyanide was painted onto art paper and left to dry overnight. Atkins laid flowers, ferns, and seaweeds on top of the coated paper and exposed them to sunlight. As the ferric salts became reduced to the ferrous state, the sulfur yellow paper was solarized to a slate-blue-gray color. The print was then developed and fixed by immersion in water in the shade until the life-size white (negative) image of the specimen was revealed against a deep blue background.

Anna Atkins was ahead of her time. She was not only the earliest female photographer but also the first person to produce a book illustrated entirely with photographs. In 1843 she published the first part of a three-volume limited edition on British algae (seaweeds) from her cyanotypes, all of which were captioned with their scientific names. Here, then, is an example of photography being used to aid the scientific study of plants. By the 1870s a cyanotype paper was available commercially for architects to make blueprint copies.

Having experimented with the cyanotype process, I have found that the simple negative images of pressed specimens set against the blue background can portray the delicate, finely branched structure of some plants, notably grasses, better than a conventional photograph of a three-dimensional living plant. However, since the specimens have to be picked and pressed for this process, it is suitable only for abundant weeds or cultivated flowers.

If you want to experiment with this process, you can make your own sunprints by laying objects (translucent flowers work well here) on the cyanotype paper manufactured by Solargraphics or on photographic paper and exposing it with the light of an enlarger. Man Ray (1890–1976), an American artist-turned-photographer who later lived

in Paris, used this technique to produce his "Rayographs," which included some flowers.

The classically simple lines of the white calla and arum lilies, with the white funnel-like spathe enclosing the yellow spadix, have inspired many a photographer—not least monochrome workers—to create still-life studies. The book *Flora Photographica*, a celebration of the artistic interpretation of flowers from 1835 to modern times, includes nineteen images of calla lilies by fifteen different photographers.

Blooms laid on Cibachrome paper and exposed to the light of an enlarger can produce some stunning color positive images against a white background. Simple flowers with translucent petals, such as poppies, work best. Unfortunately, there is not room to elaborate on these specialized techniques here.

Why Photograph Flowers?

Many people assume—quite erroneously—that flowers are easy subjects. Much of my time is spent photographing wildlife, and I am all too familiar with the frustrations and disappointments involved; nonetheless, I would argue that flower photography can be even more challenging.

First, although plants are fixed and cannot run away, they can be blown persistently by wind. Plants don't engage in spectacular behavior or make intriguing facial expressions, so the photographer has to work much harder to make a flower picture arrest the eye. Armed with a telephoto lens, it is relatively easy to take a reasonable photograph of an African elephant from a jeep, whereas it takes much more ingenuity—and time—to get an interesting picture of a plant with insignificant flowers that blend in with their surroundings. Second, flowers are ephemeral, and timing is crucial for perfect blooms. Some last only a matter of hours, and a few open briefly at night. Each kind of plant blooms for only a

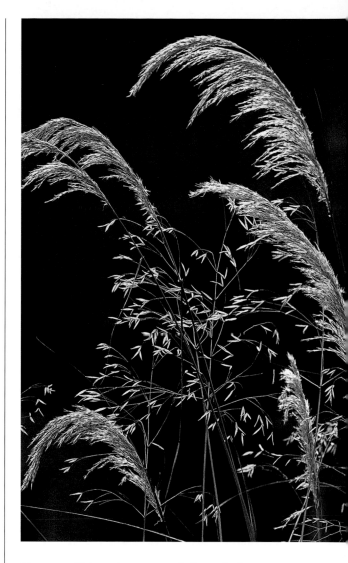

Grasses *(Stipa gigantea* and *Cortaderia richardii)* at Kew Gardens, London, England, August. *Nikon F4, 500mm f/5.6 Nikkor lens, Kodachrome 200 Professional.*

Grass flowers are never easy to photograph. These grasses backlit against a background in shadow invited me to take them. But as I moved in closer, some sky appeared in the upper part of the frame. I decided to retreat and use a 500mm lens (which I was carrying to photograph water birds) so that the grasses filled the frame.

April wildflowers beneath oak tree in field near Cuero, Texas, with yellow coreopsis and red *Phlox drummondii. Hasselblad 500 C/M, 150mm f/4 Sonnar lens, Ektachrome 100S.*

Rain is the trigger for a profusion of annual wildflowers to germinate and bloom. In Texas, after the bluebonnets begin to fade, a succession of different-colored wildflowers appears, providing endless subject material for wide- and medium-range shots as well as close-ups.

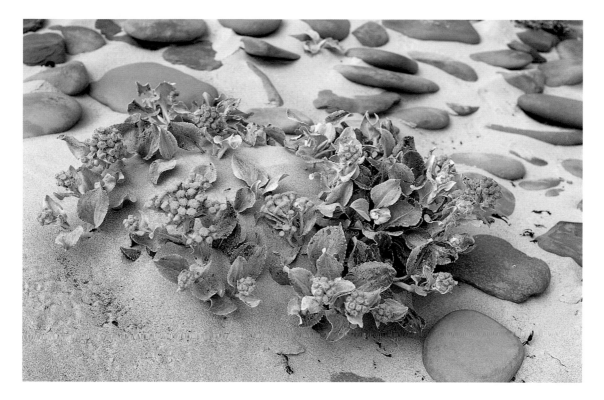

Sea cabbage *(Senecio candicans),* Sea Lion Island, Falkland Islands, December. *Hasselblad 500 C/M, 80mm f/2.8 Planar lens, Ektachrome 100S.*

This maritime plant grows in pure sand just above the tide line. I was fascinated by the way the yellow blooms emerging from the woolly coated silvery leaves mimic the yellow lichens on the gray stones, so I chose a standard lens to include both in the same picture. A slightly higher view from a small stepladder would have enabled me to get both the sea cabbage and the stones behind in focus. As it was a windy day, I was unable to use a slow shutter speed to fully stop down the lens.

limited time, and if you get the timing wrong, you may have to wait a whole year for another opportunity to take that flower.

There are many ways for a flower photographer with skill and ingenuity to produce memorable floral studies. Some individual flowers, such as exotic orchids, are so exquisitely beautiful that they openly invite you to photograph them; others may be less appealing as portrait studies but nevertheless make a good subject if lit in a striking way. During landmark years with optimum weather conditions, massed floral displays in South Africa's Namaqualand or the Texas prairies produce expansive carpets of color. Here a photograph can consist of blocks of color within the landscape or home in on several different kinds of plants growing together.

The motivation for photographing flowers varies from one person to another. Often it is simply a desire to record their beauty. Some photographers will be inspired by the shape and form or color of

Heart of a tulip flower, author's studio. *Nikon F4, 105mm AF f/2.8mm Micro-Nikkor lens, Fuji Velvia.*

As I was about to relegate a bowl of dying tulips to the compost heap, I looked twice at the heart of the flower. The colors had attracted me to buy the tulips in the first place, and now the distorted central petals curving around the stigma gave me an idea. Using a magnification of life-size on the film, along with a wide-open aperture to produce minimal depth of field, I was able to create an abstract impression of a jaded—but nonetheless photogenic—tulip.

documenting the succession of flowers that appear in a nature preserve, entering photo competitions, producing slides for lecturing, illustrating articles, producing photo cards, self-publishing, or even writing a book. Accurate identification is essential when botanical illustrators need to refer to color photographs during a season when plants are no longer in flower.

As a scientist, my initial approach to flower photography was to document what I saw. My future parents-in-law enjoyed searching for British wild orchids, and these are among my first flower photographs. Looking back at these pictures, they are no more than straight records; although the exposures are consistent, the lighting is unimaginative. It never occurred to me to use a reflector, diffuser, or flash.

Over the years, I have come to appreciate that it may take a great deal of time and effort to produce a memorable flower photograph. None of those included in this book were casual, spur-of-the-moment shots. Apart from the cyanotype, they were all taken using a tripod and achieved as the result of many decisions. I carefully chose the location, the individual plant, the film, the lens, the camera angle, the combination of aperture and shutter speed, and the

flowers without having the slightest desire to identify them. If your aim is to produce art prints, then botanical names are immaterial. However, as you spend more and more time focusing on flowers, you will better appreciate their structure, which in turn will lead to a desire to identify what you have photographed.

Learning to recognize specific flowers or flower families will open the door to a host of goals and projects. These may include

depth of field. All this may sound very complicated, but with experience, the choice of most options becomes easier and virtually instantaneous. Fine-tuning may involve adjusting the framing and deciding whether to use a filter, reflector, diffuser, or flash.

Inextricably linked with decisions about the possible options is whether you want a straight scientific record or an artistic interpretation of a flower. The former necessitates a reasonable depth of field usually coupled with an authentic color reproduction (photography by ultraviolet light or using infrared film will give false color) without distortion of the floral structure. The latter may involve minimal sharpness (depth of field), blurred images, deliberately changing the color, or abstracting part of the whole. Multiple images on a single frame can be used to clinically illustrate how a flower bud opens against a black background or to create a painterly picture when the camera is slightly moved between exposures (see page 62–63). The choice is yours, and it will depend on how you wish to use your pictures.

Even without using creative techniques, one kind of flower offers scope for a wide variety of interpretations simply depending on how you frame the photograph. I have taken a cistus and photographed it in three different ways (pages 10–11). The fact that each picture portrays a different facet makes it difficult, if not impossible, to judge which is best, but together they illustrate how it is possible to vary the picture with the choice of lens and the way the subject is cropped.

Today we have many options for flower photography. We can revive historic photographic processes, take straight color prints or slides, produce time-lapse pictures, make multiple images, or create exciting artistic impressions from an original crisp photograph using software such as Adobe Photo Shop and a computer. All this opens the way for some highly creative possibilities.

Preparation

Whatever your approach to flower photography, if you know a rewarding area for wildflowers, relatively little planning will be needed. Before setting out, however, it is good to call a local ranger to check if it is an average season for peak bloom time or whether abnormally cold weather is likely to delay the appearance of the blooms.

If you plan to travel farther afield to a new location—even if your inspiration comes solely from chance encounters with flowers—some planning and preparation are prudent in order to avoid wasting time and money.

As an example of the way I plan a trip, I will briefly outline a quest for the prairie flowers of Texas. In 1996 I was poised to fly across the Atlantic to take pictures for this book. After making a few calls, I learned that a poor show was forecast after an abnormally dry season, so I had no option but to postpone my visit for a year. Early in March 1997 I called the National Wildflower Research Center in Austin, Texas, which confirmed that plentiful rain boded well for a promising floral pageant. I dug out a feature on Texas wildflowers that had appeared in the February–March 1996 issue of *Photo Traveler,* with detailed maps of the best wildflower routes. I photocopied the relevant pages and slipped them into clear acetate sleeves as protection against wet weather.

In late March I called the Texas Wildflower Hotline, (512) 832-4059, and was happy to learn that the peak time would coincide with my proposed trip in early April. After I arrived in Austin, my first port of call was the National Wildflower Research Center, where hundreds of native plants, all labeled with both common and scientific names, are grown on a 42-acre site. As my visit happened to be on a Friday, the day the Wildflower Hotline messages are updated, I called again and noted the areas with the best blooms in my field notebook.

Gray-leaved cistus *(Cistus albidus)*, southern Spain, April. *The showy flowers on cistus shrubs present opportunities for quite different frames. I used an incident light meter in all three cases.*

Top: Nikon F4, 80–200mm AF f/2.8 Nikkor lens, Ektachrome Lumière 100.
 The pink cistus flowers are positioned in such a way that they appear to be framing the French lavender (Lavandula staechas). This color combination is a harmonious example of a natural plant association.

Above: Nikon F4, 105mm AF f/2.8 Micro-Nikkor lens, Ektachrome Lumière 100.
 For this frame-filling portrait of a single flower after a rain shower, I chose a macro lens to detail the water drops on the crinkled petals.

Opposite page: Hasselblad 500 C/M, 80mm f/2.8 Planar lens + Proxar (close-up) lens, Ektachrome 100 Plus.
 The grouping of the flowers in the square frame makes it possible for them to be cropped into a vertical format.

Above: Wildflowers along the roadside near Cuero, Texas, include standing wine cups *(Callirhoe leiocarpa)* and white prickly poppies *(Argemone albiflora)*, April. *Nikon F4, 80–200mm AF f/2.8 Nikkor lens, Ektachrome 100S.*

The white poppies and claret wine cups are a rather subdued Texas roadside ensemble that looked perfect in soft light. The color combinations change frequently along the same stretch of road, making this part of Texas a wildflower photographer's dream.

Left: Elk thistle *(Cirsium foliosum)* with sticky geranium *(Geranium viscosissimum)* in Grand Teton National Park, Wyoming, July. *Hasselblad 500 C/M, 150mm f/4 Sonnar lens, Ektachrome Lumière 100.*

Here is an example where the backlighting happened to catch my eye as I was driving past. This chance encounter produced a picture from several not particularly distinct component parts. The thistle flowers are insignificant and lack color, but the shape of the plant is clearly defined by the backlighting. The pink geranium flowers are not very colorful, but they break up the uniform grass cover, while the backlit grass adds interest without taking the eye away from the thistle, which I deliberately placed off-center.

Southeast from Austin, many of the roadsides were enlivened by conspicuous bands of bluebonnets (wild lupines), red Indian paintbrush, and pink evening primrose. Several sources had convinced me not to miss Cuero, which promotes wildflowers in the DeWitt County lanes and byways throughout April. Nowhere in the world have I seen such a magnificent expression of everchanging natural color beside the road and in the fields. Planning certainly paid off, but I was also rewarded by luck: When the owner of a ranch saw me attempting to photograph through his fence a glorious carpet of flowers beneath old oak trees, he invited me onto his property. I was so absorbed taking both wide angles and different plant associations that I spent six hours in one field.

A bonus of working in the Cuero area was being able to visit the DeWitt County Historical Museum, which is manned by volunteers throughout April. They maintain an exhibit of live wildflowers (I counted 130 different kinds), all labeled and attractively displayed in old glass and pottery containers.

To find out about trips to botanical hot spots, browse through the advertisements in wildlife and outdoor magazines by travel companies specializing in trips to remote locations.

Whatever your motivation for photographing flowers, building up a network of like-minded people can be invaluable as you exchange ideas and learn from their experiences. Whenever I visit a new area, I make a beeline for the local botanical garden so that I can get to know some of the native plants, and I buy a flora or wildflower guide for the region.

Appropriate Equipment

Cameras

Flowers can be photographed using any type of camera, from a simple point-and-shoot to a 4×5-inch view camera or an even larger format. The panoramic format can be very effective for massed flowers in their habitat. For versatility and adaptability, however, nothing beats a single-lens reflex (SLR) system with through-the-lens (TTL) metering and a range of interchangeable lenses to cope with any situation from flowers in the landscape to close-ups.

The advantage of an SLR camera is that the image you see in the viewfinder almost exactly matches the picture that will be reproduced on film. I say almost, because many SLR viewfinders in fact show only 92 percent of the actual frame, which makes it difficult to notice distracting shapes or colors creeping into the edges. However, the extra millimeter on each side that is shot "blind" may be hidden by some slide mounts. Only the top-of-the-line models, such as Nikon F3, F4, F4S, and F5 and the Canon EOS 1N range, show precisely what will appear on film. The downside of being able to see 100 percent of the frame is that the pentaprism is bigger and heavier than on less expensive models.

For more than two decades, I have used both Nikon (35mm format) and Hasselblad (6×6cm format) systems. Why two formats?

Quite simply, I use each system for different purposes, since both have their pros and cons. In my experience, the preferred format choice depends on what you want to do with your pictures. If you want to use them for lecturing but don't want to produce large art prints, the 35mm format is more suitable. If, on the other hand, you want your pictures to be reproduced in magazines or books, it all depends on how the client views the transparencies. Provided they are examined on a light box with a magnifier, there is no reason why good-quality 35mm shots should not be selected. If, however, no light box is available and the selection is made by waving the transparencies in front of a window (believe me, this has happened), then the bigger the transparency, the better. I have put this to the test by submitting identical subjects taken on both formats; the larger format won every time. Calendar clients tend to favor larger formats, too, but this can be overcome by making 70mm dupes of 35mm originals.

So far as the photographer goes, 35mm is more versatile, since it offers a much wider range of lenses and films. With the superb definition of today's color film emulsions, however, I find that the limited choice of medium-format films is not a problem. One of the big pluses in favor of using a medium format, such as a Hasselblad, is the inter-

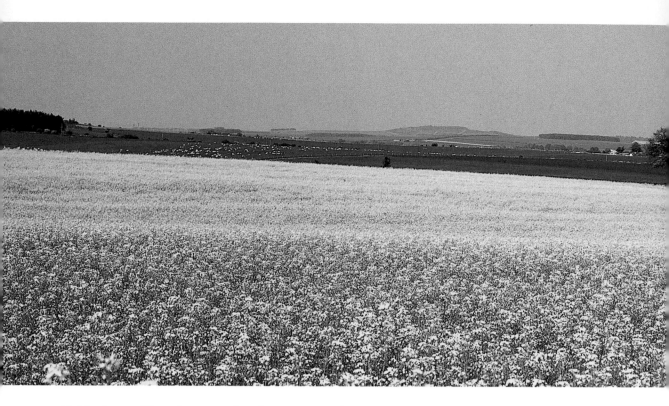

Field of rape *(Brassica napus)* in flower, Berkshire, England, May. *Hasselblad 500 C/M, 60mm f/3.5 Distagon lens, Ekta-chrome 64.*

Although this view was taken on a square format, I planned to crop the landscape as reproduced here. Extensive blocks of color in the landscape are ideal subjects for taking panoramic pictures from an elevated viewpoint.

changeable film magazines, which allow you to change the film speed in midroll without any waste. The innovative Advanced Photographic System (APS) also permits a film to be changed midroll. When more SLR APS cameras are launched and the price drops, this will be a very attractive feature for smaller format users.

Any medium-format system certainly slows down the picture-taking process; changing the standard twelve-exposure roll won't occur three times as quickly as taking a thirty-six-exposure 35mm roll. On the downside is the high price of the system, as well as the increased cost of film and development.

For me, a bonus of the square medium format is that, provided the subject does not fill the frame, it offers a designer much more flexibility. The picture can be used as an uncropped square as originally taken or cropped as a vertical or a horizontal image. Also, radially symmetrical flowers such as a water lily, a sunflower, or a rose fit more naturally within the square frame.

For this book there were no stipulations, and the choice of pictures was determined by the subject and the photographic context. The final ratio turned out to be 3:1 in favor of 35mm, which is not surprising, considering that I shoot much more on this format.

I know a few flower photographers who use twin-lens reflex (TLR) cameras as a cheaper alternative to SLR 6×6cm cameras. These are fine for general scenics, but they have their limitations when it comes to accurately framing close-ups.

Whenever I am asked for advice about the best camera to buy for flower photography, I avoid being too specific. Invariably the choice is restricted by price, and then it boils down to what feels comfortable in the hand. Even if you initially invest in a camera plus one or two lenses, it is worth considering the system as a whole, because sooner or later you may need to expand it. If possible, try to borrow or rent a camera to use for a week or two. It is one thing to handle a camera in a shop with an eager sales assistant hovering over you, but it is quite another to test it at your leisure outside. Since few camera dealers are avid flower photographers, it pays to be armed with a list of questions.

As cameras are becoming more and more automated, it is essential to discover whether the autoexposure determination and autofocus (AF) can be overridden with manual options. Unless you prefer to use a separate, hand-held meter, you also need to know how the camera meters a scene. Which of the following exposure metering options does it offer?

• *Matrix*—takes several readings all over the scene and averages them.

• *Center-weighted*—meters all over, with the emphasis in the center.

• *Spot*—precisely meters one or several small areas within the frame.

While matrix metering will cope with the majority of flower pictures, it is extremely useful to be able to precisely spot-meter a small part of the frame, such as a backlit leaf.

Does the camera offer a choice of metering modes? If you are even semiserious about your photography, you can forget the program autoexposure mode, where the camera selects the aperture and the shutter speed, allowing you no control whatsoever. I invariably stick with the manual exposure mode so that I can select the combination of aperture and shutter speed that best suits each particular subject. Other exposure modes include the aperture priority mode, where you select the aperture and the camera sets the shutter speed, which can be useful when you require a precise depth of field and the light is constantly changing; and the shutter priority mode, where you select the shutter speed and leave the choice of aperture to the camera, useful when you want to photograph fast-moving subjects by freezing (fast shutter speed) or blurring (slow shutter speed) the motion.

You should also know precisely where in the camera the meter reading is made. Off-the-film-plane metering (OFM) is highly accurate, since it measures the light precisely where the film will be exposed.

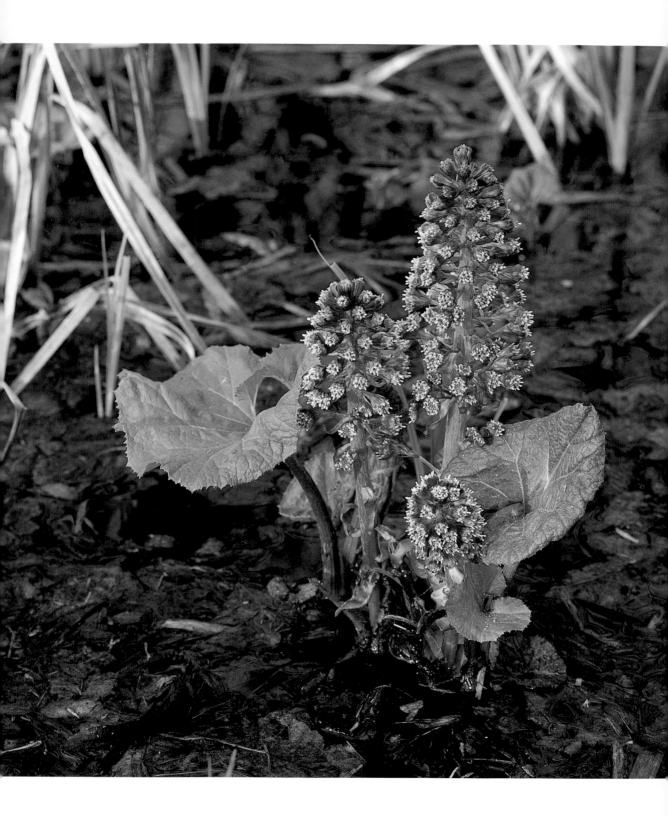

Butterbur *(Petasites hybridus)*, Hampshire, England, March.

These two pictures illustrate my preferences for using different formats. I tend to use the square medium format for taking plants in their habitat and for portraits of larger plants. This was perfect for framing the entire plant in a wet ditch (opposite page), since it allowed space for cropping to a vertical format. A macro lens, on the other hand, is an ideal choice for a tight close-up crop on a few flowers with their buds (below). After the butterbur flowers wither, the leaves enlarge to the size of a small umbrella, and before the invention of refrigerators, they were used for wrapping up butter to keep it cool.

Opposite page: Hasselblad 500 C/M, 150mm f/4 Sonnar lens, Ektachrome 64.

Below: Nikon F3, 105mm f/3.5 Micro-Nikkor lens, Kodachrome 25.

Additional questions to ask before buying a camera include the following:

Does it have a mirror lock-up feature? This is invaluable when using shutter speeds of 1/8 of a second or slower.

Does it have a depth-of-field preview button? This is used to determine which aperture is most appropriate to give you the depth of field you require.

Does it have a cable or an electronic shutter release? One of these options is essential to ensure the camera is not moved during a long exposure.

Is there a feature that allows for multiple exposures? Though this is not essential, it is useful if you want to create multiple-exposure shots.

Is a lens shade included with the lens? Sadly, all too few lenses are sold complete with a lens shade; usually this is an

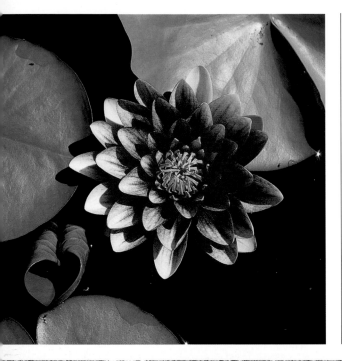

Water lily *(Nymphaea "Attraction")* in author's garden pond, Surrey, England, June. *Hasselblad 500 C/M, 150mm f/4 Sonnar lens, Ektachrome 100 Plus.*

If a portrait of a radially symmetrical flower does not fill a square 6×6cm format, it can be cropped as desired. In this case, I made sure not to fill the frame with the water lily so that it could be used uncropped as a square picture, cropped at the sides for a vertical cover, or cropped top and bottom to make a horizontal picture.

Bluebells *(Hyacinthoides non-scripta)* with ferns, Scotland, May. *Nikon F4, 35–70mm AF f/2.8D Nikkor lens, Ektachrome 100 Plus.*

Metering this spring cameo was easy. Because the tree trunk, green ferns, and bluebells were all a medium tone, I could use the matrix in-camera reading. Alternatively, I could have spot-metered the green ferns.

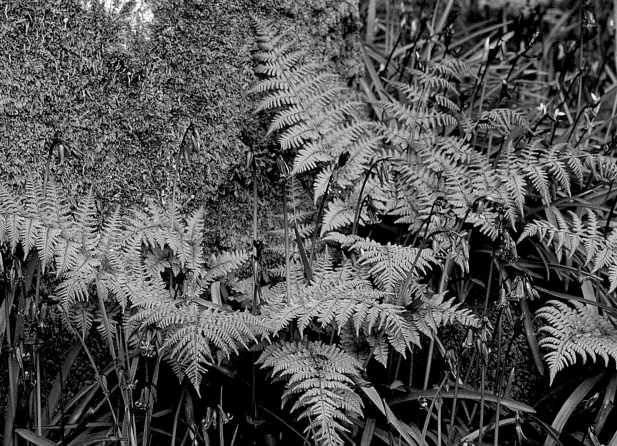

optional extra. Yet a shade not only prevents flare, whereby direct rays from the sun falling on the front lens element cause bright spots to appear in the picture, but also helps protect the lens from rain or snow and from damage if it is accidentally dropped. More than once I have slipped on ice and have been thankful that I ended up with only a dented lens shade. When using a zoom lens, any shade is something of a compromise; if it is too long, it will cause vignetting at the corners of the frame at the widest angle, and if it is too short, it won't adequately restrict stray light when used at the longest focal length. One solution is to use a rubber lens shade that can

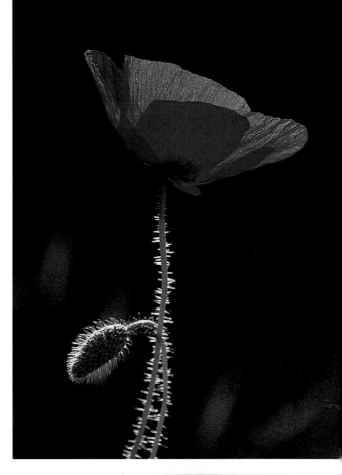

Poppy *(Papaver rhoeas)* taken early in the morning in Surrey, England, June. *Nikon F4, 105mm AF f/2.8 Micro-Nikkor lens, Kodachrome 200 Professional.*

Because of the large area of shadow behind this backlit poppy, I could not use a matrix in-camera reading, so I spot-metered the light through the upper parts of the petals. Notice how the backlighting has accentuated the hairy stem.

Salsify or purple goatsbeard *(Tragopogon sinuatus),* Cyprus, April. *Nikon F4, 105mm AF f/2.8 Micro-Nikkor lens, Ektachrome 100 Plus.*

Long-stalked, flat-headed flowers belonging to the daisy family, such as salsify, tend to sway in the slightest breeze. The obligatory fast shutter speed (1/250 second) needed to freeze the movement, at a magnification of half life-size, gave me an aperture of f/5.6. This aperture resulted in a small depth of field, but it was enough to ensure that the flower head stood out from the out-of-focus background. Since these flowers close at noon, they have to be photographed in the morning.

be extended for use at the longer end of a zoom or contracted when using wider angles.

Features such as speedy autofocus, high-speed motor drive, and auto built-in flash, although proudly promoted by camera manufacturers, are irrelevant so far as flower photography goes, so don't be enticed by these. Indeed, even a slow motor drive is not essential, but unless you go for a good secondhand model, not many cameras come without one nowadays.

I have judged many photographic competitions over the years, and lately I have been noticing an increasing number of pic-

tures with the subject out of focus or with an inappropriate depth of field. I am convinced this is due to misuse of the autofocus system. On a windy day, any object onto which the AF system locks, whether it be the subject or a branch, will appear sharply defined. As explained in Part VI, understanding depth of field and hyperfocal distance is paramount to the success of flower photography, but if you stick with an AF system you will never learn these fundamentals toward achieving more rewarding and creative photographs.

One feature that should be avoided at all costs is a built-in flash that automatically fires when there is not enough light. In poor light, provided there is not a continuous wind blowing, most flowers can be taken using long exposures. If flash is necessary, the last thing you want to use is uncreative front light.

To recap, the following table shows which features are useful and which are inessential when considering buying a camera for flower photography.

Yellow daisies *(Senecio littoralis)* on Jason Island, Falkland Islands, December. *Nikon F4, 20–35mm AF f/2.8D Nikkor lens, Ektachrome 100S.*

By using a low camera angle and a wide-angle lens, I was able to show the 45-degree slope on which the daisies were growing, together with the maritime habitat.

	Useful	Inessential
Ability to override autoexposure mode	X	
Depth-of-field preview button	X	
Mirror lock-up	X	
Cable or electronic shutter release	X	
Multiple-exposure feature	X	
Program mode		X
Autofocus		X
Motor drive		X
Auto built-in flash		X

Lenses

With such a plethora of lenses available, it can be a nightmare deciding which ones are most appropriate. If you asked six different professionals, you probably would get six different answers.

Aside from the price, there are two main factors to consider when buying a lens: the focal length, given in millimeters, and the maximum aperture, either prefixed with an f (such as f/2.8) or given as a number before the focal length (such as 2.8/50) on the lens itself. A lens with a wide maximum aperture, such as f/2 or f/1.8, is known as a "fast"

Yellow daisy *(Senecio littoralis)* on Jason Island, Falkland Islands, December. *Nikon F4, 105mm AF f/2.8 Micro-Nikkor lens, Kodachrome 200 Professional.*

Unlike the wide-angle shot, this picture gives no information about the habitat. It does, however, graphically illustrate how the plant is thriving on the lee side of a rock, which suggests that it grows in a windswept habitat.

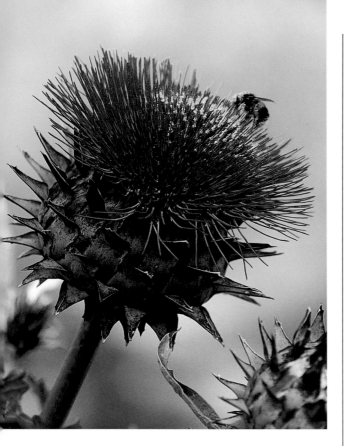

Globe artichoke *(Cynara scolymus),* Kew Gardens, Surrey, England, July. *Nikon F4, 80–200mm AF f/2.8 Nikkor lens, Ektachrome Lumière 100.*

Viewed against the out-of-focus sunlit grass, this majestic flower leaps out from the background. Metering this shot was not straightforward, however. To use the camera's matrix mode, I turned around 180 degrees and metered off the green grass beside me, then opened up half a stop. It was a bonus getting the bumblebee covered with pollen.

lens and is invaluable for photojournalists or sports photographers working with moving subjects in poor light. When using a tripod to photograph flowers, however, you will rarely opt to work with the lens wide open, since this will give you minimal depth of field. Fast lenses are more expensive than slower lenses, so you can save money here.

The standard or normal focal length for a 35mm format is a 50mm lens. Shorter lenses, such as 35mm, 28mm, or 24mm, are known as wide-angle lenses. Since they take in a broad angle of view, they are a good choice for taking plants in their habitat. A long or telephoto lens has a focal length longer than 50mm and is useful for taking flowers growing on inaccessible cliffs, climbers high up trees, or plants growing in a swamp or across the far side of a river or lake.

Successively longer lenses change the perspective by taking in a narrower angle of view as the image size increases. They also decrease the depth of field and hence are invaluable for blurring the background and making the flower stand out from the vegetation behind. The longer the lens, the greater the working distance between the camera and the plant, which provides more room for holding a reflector or a diffuser in place.

Zoom lenses span a range of focal lengths and can be useful when traveling abroad, since they cut down the range of lenses you need to take. In addition, one zoom will cost less than two or more prime lenses.

Other considerations when buying a lens are the minimum focusing distance (although this can be reduced by inserting a small extension ring between the camera and the lens) and the weight.

I use an extremely wide range of lenses to photograph flowers, anything from 20mm to 500mm, but if I were limited to just three, I would settle for the following superb Nikkor lenses: the 20–35mm zoom, which covers all wide-angle situations; the 105mm micro; and the 50–300mm zoom. (I very rarely use a prime standard lens.) Together these three lenses give me a huge range. If I were starting from scratch, however, I might well go for a 28–50mm, a 105mm micro, and an 80–200mm telephoto, which would cost much less.

For those readers who are not familiar with medium-format systems, the Hasselblad standard lens is 80mm; the wide angles are 60mm, 50mm, and the 38mm Superwide; and the telephotos range from 150mm to 500mm.

Supporting the Camera

A tripod serves three functions: It prevents camera shake, it allows for an increased depth of field through the use of slower shutter speeds, and it slows down the whole picture-taking process, thereby allowing a more critical appraisal of the framing. A tripod must provide rigid camera support; one with legs that are wobbly or prone to collapse is useless and you are better off scrapping it.

There are several factors to consider when buying a tripod. Since relatively few flowers open at eye level, you need a tripod that is capable of supporting the camera close to the ground. I have used the British-made Benbo for a quarter of a century. The name comes from the tripod's **bent bo**lt, which allows the legs and the center column to be positioned at any angle. This versatile tripod can be used for conventional eye-level landscapes one moment and, by simply unlocking the bolt, laid prone the next. What is more, since the lowermost leg sections are the widest, the tripod can be safely immersed in water up to a depth of 21 inches.

Flame of Irian *(Mucuna bennettii)* Kalimantan, Indonesia, April. *Nikon F4, 200–400mm f/4 Nikkor lens, Ektachrome Lumière 100.*

The dazzling scarlet flowers are produced by a woody climber high up in large trees, so the only way I could get a reasonably close shot was by using a long telephoto lens. Although it's heavy and quite impossible to hand-hold, this long-range zoom is one of my favorite lenses for taking wildlife.

Other tripods suitable for low-level flower photography include Gitzo and Bogen models with a center column that can be reduced in height and the legs splayed out, or with a center column that is reversible so that the camera can be mounted close to the ground.

When you plan a trip to the mountains, weight should be kept to a minimum, but a tripod is still an asset. In this case I would suggest looking at the Gitzo Mountaineer series with carbon fiber legs. The light-

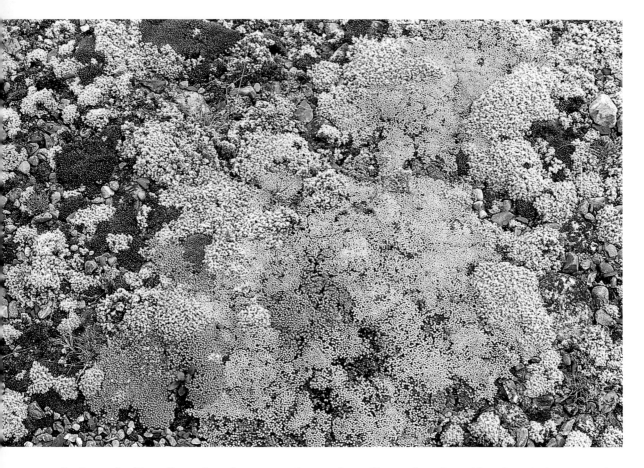

Scabweeds *(Raoulia sp.)* and moss on dry riverbed in Mount Cook National Park, New Zealand, November. *Nikon F4, 105mm AF f/2.8 Micro-Nikkor lens, Ektachrome 100S.*

The versatile Benbo tripod enabled me to speedily maneuver the camera with the back (and hence the film plane) parallel with the ground. In this way I could ensure that the entire frame, with the mosaic of scabweeds and mosses carpeting the pebbles, would appear in focus.

weight 1508 gram model (slightly over 3 pounds) may cost a lot but it is very convenient, collapses down to 21 inches (without a head), and can be easily lashed onto a photo backpack.

If you do a lot of low-level photography, you might consider using a lowpod made by Kirk Enterprises for supporting the camera at ground level. An inexpensive version of the lowpod can be made simply by attaching a small ball-and-socket head to a 6×4-inch piece of wood. An alternative low-level support is a ground spike made by Cullmann, but this has limited use, as it cannot be used on a rocky substrate or on very soft boggy ground. Whatever low-level support you choose, investing in a right-angle viewfinder will mean you don't have to lie prone to focus the camera as with the standard viewfinder.

Once you have chosen a camera support, your next decision is what kind of head to buy. When working with a 35mm format, it

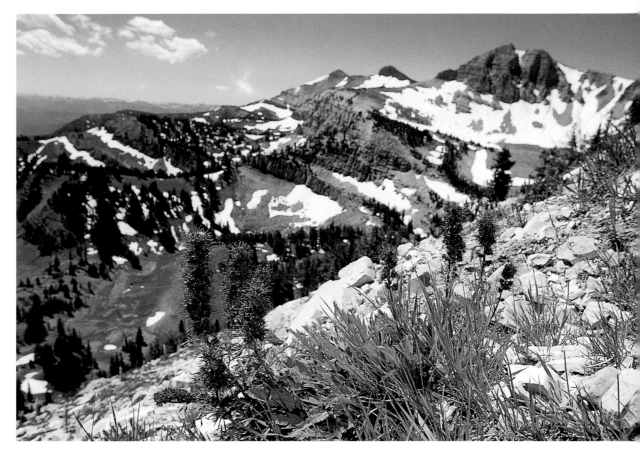

is crucial to get one that enables you to speedily change from a vertical to a horizontal format and back again. I gave up using pan-and-tilt heads years ago, since the handle always dug me in the chest whenever I bent down to take close-ups. Over the years I have used a variety of large ball-and-socket heads, including the Arca Swiss mono-ball. Currently I am using a Foba superball, which weighs almost 3 pounds (1274 grams). This may seem like using a sledgehammer to crack a peanut, but since I also do a lot of wildlife photography, this will safely support a camera with a 500mm or even 600mm lens. Such a weighty head is by no means essential when using shorter and lighter lenses for flower photography.

Silky phacelia *(Phacelia sericea)* growing above 10,000 feet on Rendezvous Mountain, Wyoming, July. *Nikon F4, 20–35mm AF f/2.8 Nikkor lens, Ektachrome 100S.*

I used the Jackson Hole Ski Resort aerial tram as a speedy way to get up to 10,450 feet with my gear. By using a wide-angle lens as well as a low camera angle, I was able to include the mountain backdrop with the sun shining onto the plant from behind. I had to use fill flash to eradicate the shadows on the side of the flower nearest the camera.

Finally, when changing camera bodies or when removing a camera with a short lens and replacing it with a long lens complete with its own tripod mount, a quick-release

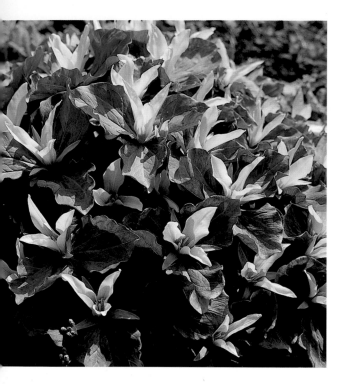 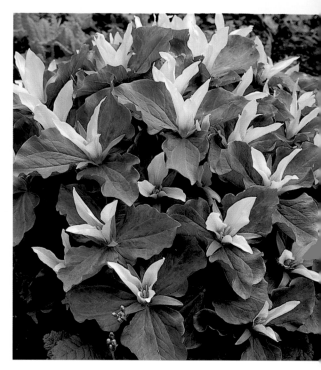

Large-flowered trillium *(Trillium chloropetolum)* flowers, Kew Gardens, Surrey, England, April. *Hasselblad 500 C/M, 150mm f/4 Sonnar lens, Ektachrome 100 Plus.*

Above left: When highly three-dimensional flowers, such as trillium, are lit by direct sun, they cast confusing shadows across the leaves.

Above right: Use of a diffuser helps to simplify the picture by softening the light and thereby eradicating the harsh shadows.

plate will help save valuable shooting time. Hasselblad makes its own, but since I constantly change cameras and formats, I prefer to stick with plates made by Kirk Enterprises. You will need to fit a base to the ball-and-socket head and a top to each camera body and any long lens that has its own tripod bushing.

Accessories

A cable release is every bit as essential as a sturdy tripod for ensuring crisp pictures taken with a slow shutter speed, and no flower photographer should leave home without one. I always carry at least a couple in case I lose one, although since I started adding stripes with yellow insulating tape, they are much easier to locate in long grass or leaves.

A reflector and a diffuser are essential for controlling natural light when taking close-ups of flowers. (Other close-up accessories are discussed in detail in part 8.) An electronic flash is another invaluable lighting tool, especially if it is a dedicated TTL flash model specifically designed for use with your camera.

No matter what the habitat, the recurring problem that bugs all flower photographers to a greater or lesser degree is a persistent wind. Even if you opt for a fast film so that

you can use a fast shutter speed, focusing becomes somewhat hit or miss. When using a vehicle as a base, I can use a trapezoid windshield made from four pieces of clear Plexiglas (three side walls and a top). The base covers an area of 20×20 inches and the top is 12×12 inches. If the back wall is clean and scratch free, it will provide a clear view of the habitat behind a clump of plants enclosed within the windshield. Using a low viewpoint, I shoot through the open side. Many a time I have been able to photograph a stationary erect plant while neighboring ones outside the shield were constantly blown around.

Additional inexpensive but useful items include a large plastic trash bag for kneeling on wet ground, gardener's kneeling pads to

Raindrops on juniper needles, author's garden, July. *Nikon F4 105mm AF f/2.8 Micro-Nikkor lens, Ektachrome Lumière 100.*

Instead of a more obvious shot of rain on a flower, I chose a macro shot of raindrops functioning as miniature fish-eye lenses. In each drop the reversed image of the nearby red peony flower can be seen. To take this picture in the rain, I held a clear umbrella over the camera mounted on the tripod. I stopped the lens down well, as the image appears life-size on the film.

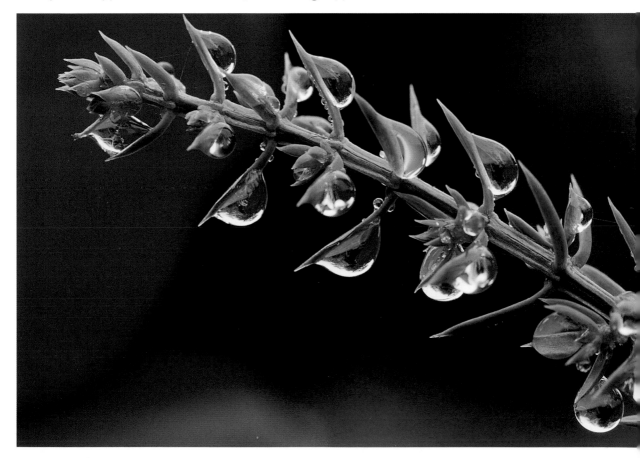

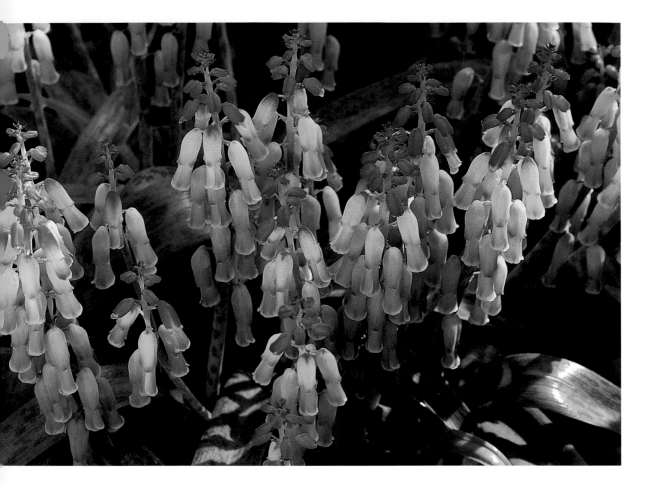

Lachenalia 'Tricolor' in Alpine House, Kew Gardens, Surrey, England, April. *Nikon F4, 105mm AF f/2.8 Micro-Nikkor lens, Kodachrome 25 with reflector.*

Oblique early-morning light spotlit the right sides of the fiery flowers produced by the spring bulbs, so I was glad I had a reflector in my photo pack to fill in the shadows on the left side of the blooms.

cushion hard rocks, and a long length of tape or string for tying branches back from the field of view. When working in rain, an umbrella and a plastic bag or shower cap are useful for protecting the camera. Don't forget a pen or a pack of self-adhesive num-

bers for marking each roll of film. By listing the subjects consecutively in my field notebook, I can speedily locate a picture of a particular flower on return from a trip. For a more complete description of how to use these and many other gadgets, see my book *Outdoor Photography: 101 Tips and Hints.*

Carrying Gear

Another important consideration in flower photography is choosing the most suitable—and comfortable—way of carrying your photo equipment in the field.

Photo vests are fine, but avoid overloading them or you can end up being front heavy. I use one most of the time for stashing filters, close-up lenses, cable releases,

and most important, my field notebook. For hot climates, make sure you get a vest made of a material that breathes.

A fanny pack can be useful for carrying film. If it has at least two compartments, one can be used for unexposed rolls and another for exposed rolls.

Whoever designed outsize gadget bags with a single strap must have never used them fully loaded out in the field. They result in a lopsided body, which can play havoc with your spine. My advice would be to forget them and go for one of the many photo backpacks that have padded shoulder straps and a wide waist belt. I use several different sizes, depending on the length of the trip. The Domke Outpack series is both robust and versatile, and its daypack is ideal for flower photography. It comes complete with a weatherproof cover that prevents rain or snow from getting into the pack via the zip fasteners.

It is all too easy to become so weighed down with equipment that it impedes your progress. If you prefer working from the back of a vehicle, weight won't be a problem. Outside of Texas, however, the best flowers rarely hug the roadside, and in this situation they tend to be blown around by passing traffic. When backpacking, keep equipment to a minimum. It usually takes a few trips to fine-tune the best mix of essentials with items you may need in an emergency. After each trip, note anything you neglected to take that would have been useful.

My own checklist for 35mm flower photography in low-altitude locations follows. This is pruned down when I climb mountains.

two Nikon F4 bodies
20–35mm f/2.8D Nikkor
35–70mm f/2.8D Nikkor
80–200mm f/2.8 Nikkor
300mm f/4 Nikkor
105mm f/2.8 Micro-Nikkor
extension rings
close-up lenses
polarizing filter
gray graduated filter
neutral-density filter
haze filter
warm-up filter
tape for tying back branches
reflector
diffuser
flash with extension sync cord
two cable releases
right-angle viewfinder
Benbo tripod
various films
fanny pack for carrying film
field notebook
self-adhesive numbered labels
trash bag for kneeling on wet ground
umbrella

However, I would suggest that getting to know your equipment so you can speedily set up a camera in fading light is infinitely preferable to accumulating another gadget.

Films and Exposure

Films

With such a wide choice of films now available, how do you choose the best one for flower photography? First, you need to decide what you plan to do with your flower pictures. If you want to produce prints only, then color negative film will be the obvious choice (although prints can be made from slides). On the other hand, if you aspire to having pictures reproduced in magazines or books, in calendars, or on posters, you will need to use slide or transparency film.

The second decision is what film speed to use. All films, print or slide, have an ISO number, which denotes their relative sensitivity to light. The lower the number, the less sensitive the film; the higher the number, the more sensitive. In ideal conditions for plant photography—windless days in open locations with plenty of light—slow-speed film is the obvious choice, since the definition will be sharper than with fast, high-speed film. The slowest-speed transparency film available is Kodachrome 25 (ISO 25), which is closely followed by Fuji Velvia, nominally ISO 50 but rated at ISO 40 by many photographers.

Velvia and Ektachrome 100S (saturated) both have well-saturated colors that provide extra punch to pictures taken on a dull, overcast day. No two films produce identical color reproductions, and since we all see colors differently (indeed, the eyesight of 8 percent of the male population has a color deficiency), choice of which slide film is preferable will inevitably be a personal one. The rendition of color prints can, incidentally, be varied by filters used in the printing process.

The captions to the pictures reproduced in this book reveal my personal favorite films, which have changed over the years as new ones became available. Originally trained as a biologist, I strive to reproduce authentic color (or rather, color as I remember seeing it). Anyone who spends time out on location will readily appreciate that within the natural world, greens come in a great variety of tones including yellow-green, gray-green, blue-green, and dark green. For this reason, I favor using films that are able to reproduce the subtle range of greens in preference to a vivid, unnatural green.

One of the best ways of comparing films is to load two camera bodies with different film types and use the same lens to take pictures of identical subjects with both bodies. Then you can make a direct comparison by laying the unmounted transparencies side by side on a light box. Once you have found a particular film you are happy with, my advice would be to stick with it—until it is no longer produced! If I know a film will be dis-

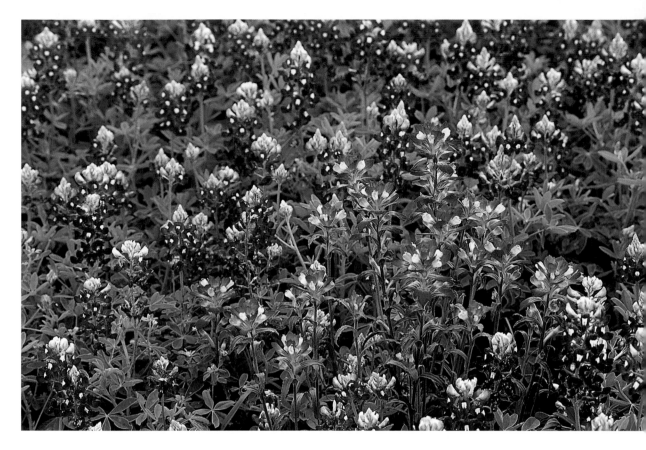

continued and I am in the middle of a project that requires the same film to be used throughout, I will buy up a good stock and keep it in a freezer, making sure to remove film rolls several hours before exposure.

When the light level drops, and particularly when plants are blowing in a breeze, medium-speed ISO 100 or 200 films are preferable, as they allow for a fast shutter speed in combination with a partially stopped-down lens. High-speed ISO 400 and 800 slide films are not suitable for general flower photography because their definition is not as sharp as slower films. It would be better to opt for one of the following alternatives: Use a windshield (see Part II), use flash for close-ups, or return on another day when the wind has abated or the light has improved.

Bluebonnets *(Lupinus texensis)* and scarlet paintbrush *(Castilleja indivisa),* near Austin, Texas, April. *Nikon F4, 80–200mm AF f/2.8 Nikkor lens, Ektachrome 100S.*

Even on an overcast day, I knew Ektachrome 100S would reproduce the saturated colors of two widespread and popular prairie flowers. I was not disappointed.

Pushing Film

If you're stuck with only slow-speed slide film when a strong wind begins to blow, and you don't want to take slow-motion blurs (see page 37), you can always "push" the film speed by uprating the nominal ISO number to gain a faster shutter speed. Uprating a 50-speed film to ISO 100 or a 100-speed film to ISO 200 will gain you one additional

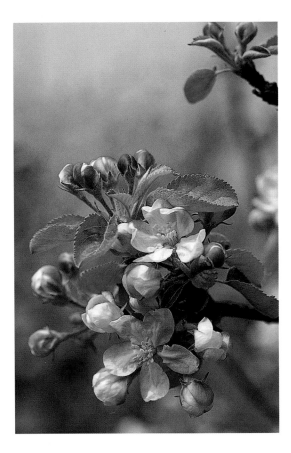

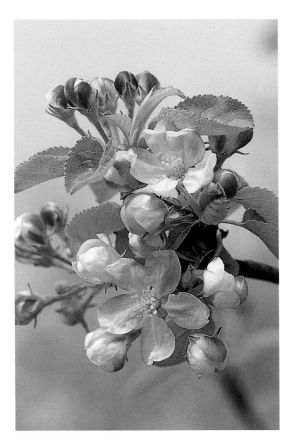

Above left: Apple blossom in a Surrey garden, England, May. *Nikon F4, 105mm AF f/2.8 Micro-Nikkor lens, Kodachrome 25.*

Above right: Apple blossom in a Surrey garden, England, May. *Nikon F4, 105mm AF f/2.8 Micro-Nikkor lens, Fuji Velvia.*

I use these two pictures in my photo workshops to illustrate the variation in colors—of greens and pinks—produced by two slow-speed slide films. The framing differs because I packed up my cameras between shots.

stop, thereby allowing either a faster shutter speed (1/250 of a second at f/5.6 instead of 1/125 of a second at f/5.6) or a smaller aperture (1/125 of a second at f/8 instead of 1/125 of a second at f/5.6) to be used.

Once the decision has been made to uprate, the entire film has to be exposed at this faster speed. After exposure, clearly mark the film with an alcohol-based pen or a self-adhesive white label, and be sure to notify the processing laboratory. There may be a surcharge for developing the film, since it has to be processed separately from other normal-rated film, but if it means getting a shot you would otherwise miss, it has to be worth it.

When using TTL metering, either reset the film-speed dial to the uprated speed or set the exposure compensation dial to −1, if your camera has one. It is important to remember to reset the dial as soon as you remove the last roll of film you want to push.

Ophrys umbilicata orchid growing on the Akanas Peninsula, Cyprus, April. *Nikon F4, 105mm Micro-Nikkor f/2.8 lens, Kodachrome 200 Professional.*

Kodachrome 200 would never be my first choice for taking a close-up. However, when faced with a persistent wind and working with a magnification of half life-size on the film, which causes a loss of one stop, you need all the speed you can get. This frame-filling shot of a single flower on the spike reveals a hairy patterned lip that mimics a spider. A small reflector helped balance the sunlight striking one side of the flower.

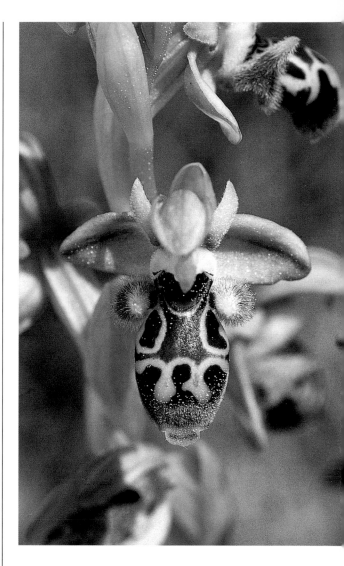

Ultrafast ISO 800 slide films can be pushed to ISO 1600 or even ISO 3200 to produce very grainy images that can be highly creative.

Exposure

At any given moment, there is one—and only one—correct exposure for a particular film speed. However, since exposure is achieved by selecting a shutter speed with a lens aperture, many different combinations are possible.

The way light exposes a film is analogous to a given volume of water coming out of a tap: It can drip for a long time (small aperture combined with a slow shutter speed) or gush out for a short time (large aperture combined with a fast shutter speed). For example, any of the following combinations will expose film to the same amount of light: 1/30 of a second at f/22; 1/60 of a second at f/16; 1/125 of a second at f/11; or 1/250 of a second at f/8.

The choice depends on many factors: the amount of light, the film speed, whether the lens is "fast" (has a large maximum aperture, such as f/2.8) or "slow" (has a small maximum aperture, such as f/5.6), whether a plant is stationary or moving, and how much depth of field is required. Therefore, if a sharp image is required, a windy day will dictate a fast shutter speed (to avoid subject blur) and a correspondingly large aperture, whereas a calm day with poor light will permit a slow shutter speed coupled with a small aperture for increased depth of field. There are rare occasions when a deliberate decision to use a slow shutter speed on a windy day pays off, such as when you wish to depict

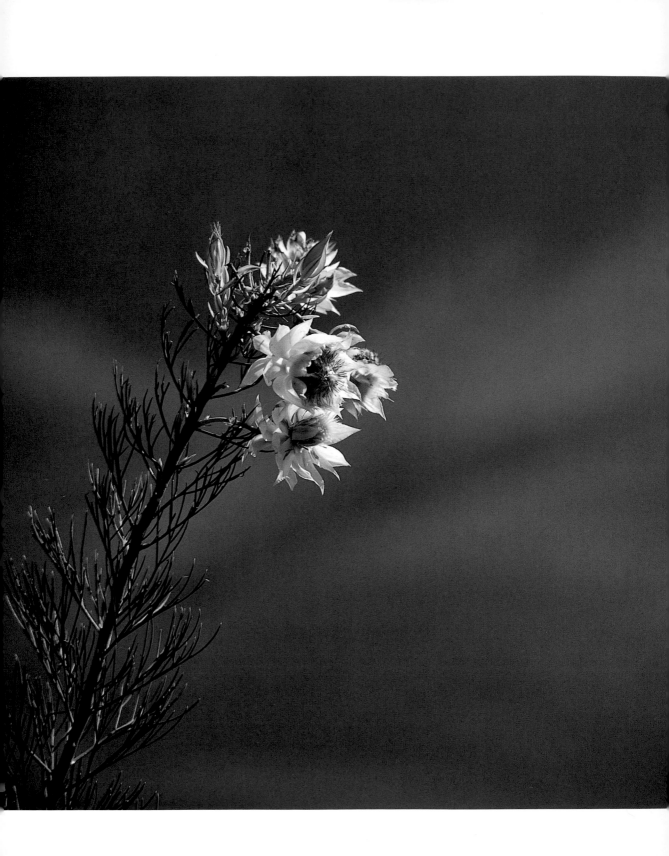

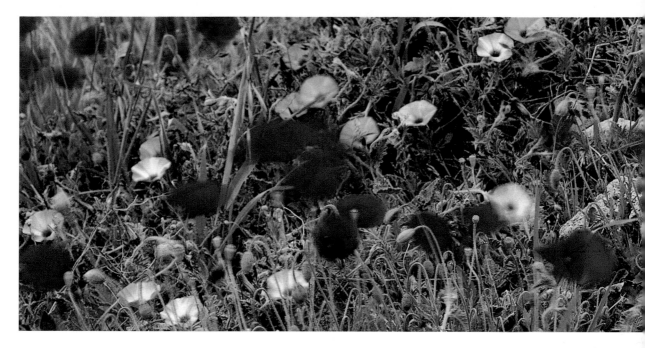

Poppies *(Papaver rhoeas)* near Cyprus, April. *Nikon F4, 200mm f/4 Micro-Nikkor lens, Kodachrome 25.*

Faced with persistent windy conditions on an overcast day, I decided it was fruitless waiting for a lull so that I could get the poppies sharply in focus. Instead, I opted for a 1/2-second exposure to produce a blurred impressionistic image as the tall-stalked poppies were blown across the frame.

a few bold-colored flowers as painterly splashes of color.

Relying on the camera's automatic exposure modes may be a quick and easy way of working, but you will get a better grasp of the relationship between shutter speed and

Left: Blushing bride *(Serruria florida),* Cape Province, South Africa, September. *Hasselblad 500 C/M, 150mm f/4 Sonnar lens, Ektachrome 64.*

A fast shutter speed (1/250 second) was needed to freeze the persistent movement of the tall-stemmed floral spray of one of South Africa's less showy proteas. This gave me a shallow depth of field, rendering the distant mountain completely out of focus.

aperture if you set them manually. Constantly using a shutter speed of 1/250 of a second so as to avoid camera shake without a tripod or subject blur can never be a creative way of working or, indeed, of maximizing the available opportunities.

Inexperienced photographers and editors of photo magazines always want to know what exposure I used for a particular photo, yet, as I point out, this is immaterial, since the odds of anyone else being in the same place with identical lighting conditions, the same lens specification, and the same film have to be infinitesimal. What is more informative, though, is why I selected a slower shutter speed to produce an impressionist blurred image of flowers or a large aperture for an out-of-focus background (see page 111).

In-Camera Metering

Modern SLR cameras that meter reflected light through the lens will provide a speedy and accurate way of metering many flower pictures. Automatic exposure modes are, however, programmed to expose pictures so that they appear as a medium tone. This is fine when the composition includes medium-toned objects, but by no means does everything we wish to photograph reflect the same amount of light.

A good way to appreciate that different-toned objects reflect light by varying degrees is to meter first off green grass, then off a white sheet laid on the grass (make sure it fills the frame), and finally off a large piece of black cloth, preferably black velvet. When doing this, make sure the available light remains constant—the sun remains shining or the cloud cover does not break up. From this exercise, it will immediately become apparent that the in-camera reading

A mosaic of roadside flowers in Texas, April. *Nikon F4, 35–70mm AF f/2.8 Nikkor lens, Ektachrome 100S.*

The mosaic of green leaves, scarlet paintbrush, and bluebonnet flowers provided a good average tone for using the matrix in-camera metering. Even though the yellow flax flowers were brighter than average, they occupied a minute area of the frame and they were compensated for by the dark wine cups and the small shadow areas.

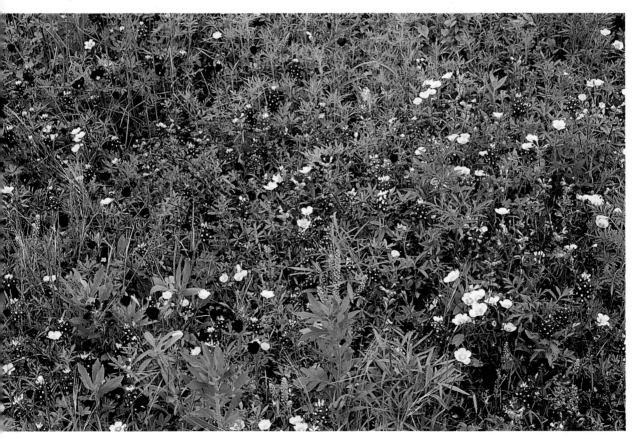

differs markedly in each case. The white sheet will reflect much more light than green grass, thereby giving a false high reading, resulting in underexposure; the black velvet will reflect very little light, resulting in a grossly overexposed picture. Yet, provided the light remained constant, only one reading will give the correct exposure—the one obtained when metering off the green grass, which is a good medium tone.

No exposure problems will arise so long as the composition includes plenty of green vegetation and flowers that are also medium-toned (not white, pale pastel, or very dark tones). On the other hand, if you rely on the camera's automatic metering modes for compositions that include a substantial area of bright sky or snow or a large patch of water or white rock—especially if the sun is reflected off it—the exposure will be incorrect. The camera's meter will record more reflectance from the bright

Toadflax (Linaria sp.) southern Spain, April. Nikon F4, 105mm AF f/2.8 Micro-Nikkor lens, Ektachrome 100 Plus.

For the camera's light meter, white limestone rocks present a problem similar to that of snow: They reflect a lot of light. Therefore, after framing this picture, I swung around and, without changing the focus on the lens, manually metered off a green shrub nearby.

area, with the result that the rest of the picture will be underexposed. (This is less critical with print films than with slide films, however, as they have a much wider exposure tolerance.)

There are several ways of solving this problem. If your camera has a manual metering mode, the simplest (and cheapest) solution is to switch over to this mode, select the lens you intend to use to compose the picture, and move the camera to

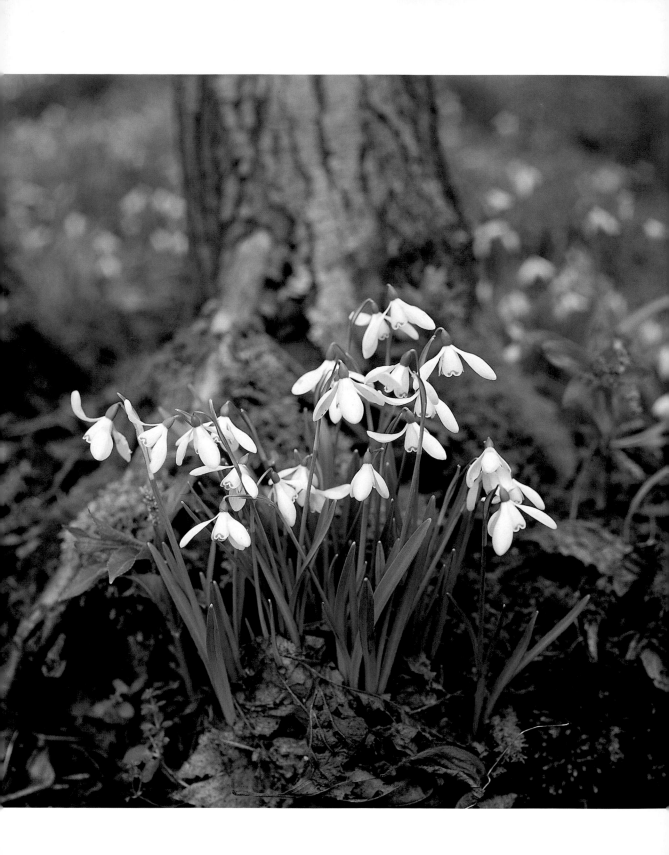

Snowdrops *(Galanthus nivalis)* in a Hampshire woodland, England, February. *Hasselblad 500 C/M, 80mm f/2.8 Planar lens, Ektachrome Lumière 100.*

Snowdrops are the harbingers of spring and may often be covered by a late snowfall. The attractive white flowers decorated with green tend to grow in shady areas and shake in the slightest breeze, making things difficult for the photographer. Within this frame, the flowers occupy only a small area; even so, I knew they would affect an overall matrix reflected light reading, so I used my Nikon to spot-meter the green mosses on the base of the tree.

meter off adjacent medium green vegetation that is lit in the same way as the subject. Then move the camera back to take the picture, including the bright areas, but using the exposure determined from the green leaves or grass. Be aware, however, that dry, bleached grass is not an average tone and will also give a false high reading.

Before TTL metering was available, handheld light meters were a necessity. They can be used to meter either the light reflected from the subject or, when a white diffusion cover is slid over the metering window, the incident light falling on it. Instead of pointing the meter toward the subject, it is turned around 180 degrees so that it measures the light falling on the subject. Nowadays, separate light meters are regarded as a dispensable luxury because of the additional cost and weight. The main disadvantage of being totally reliant on an automatic camera metering system, however, is that you won't grasp so readily when problems will arise. By using a separate light meter to take incident light readings of the same subject as the camera's reflected reading, you will come to appreciate the relationship between tonality and reflectance and will learn how to adjust the in-camera reading for nonaverage tones.

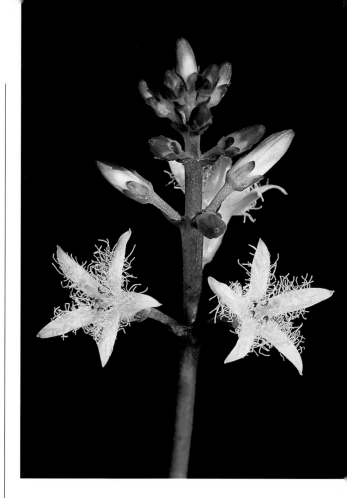

Bogbean *(Menyanthes trifoliata)*, Surrey, England, April. *Nikon F4, 105mm AF f/2.8 Micro-Nikkor lens, Ektachrome 100S.*

An early-morning start paid off when I found this aquatic plant spotlit by low-angled sunlight, which highlighted the hairy petals against the unlit water behind. The large shadow area within the frame presented a problem for metering the shot with the camera. Fortunately, bogbean has large, erect, dull green leaves that are perfect for spot metering.

If you don't want to invest in a separate light meter, it is possible to convert a camera into an incident light meter by placing a white translucent plastic cover over the lens. I have used white tops of aerosol cans and even lids of plastic ice cream containers. Before relying on this method of meter-

ing, it is important to calibrate the diffusion cap. This is done quite simply by taking a reflected meter reading (using a matrix or center-weighted mode) off green grass without the diffusion cap. Then, using the same lens and setting (make sure the light remains constant), attach the diffusion cap to the front of the lens and point the camera up away from the grass toward the sky. If the second reading is higher than the first one, the diffuser is letting in too much light. This can be reduced by adding successive layers of white typing paper inside the cap, until the two readings coincide.

Taking photographs of flowers with an extensive shadow area, or growing on black volcanic rocks or black sand beaches, is just as problematical as taking pictures of flowers poking up through snow, although with the large dark areas, the camera's TTL

Top left: A formal red and white spring planting, Kew Gardens, Surrey, England, April. *Nikon F4, 80–200mm AF f/2.8 Nikkor lens, Ektachrome Lumière 100.*

The white ground cover made this akin to photographing flowers growing out of snow. Metering this tricky subject was a task I set for students at one of my Kew Gardens photo workshops. Like me, some used a manual reading off adjacent green grass. Others used an incident light meter, and one person metered off a Kodak 18 percent gray card.

Many-flowered phlox *(Phlox multiflora)* on Rendezvous Mountain, Wyoming, July. *Nikon F4, 105mm AF f/2.8 Micro-Nikkor lens.*

When I found these frame-filling white flowers, they were lit by direct sun, with some parts in shadow. I decided to even out the lighting by holding a diffuser between the sun and the flowers. Then I metered for the flowers using a large, medium green leaf with a matte surface, also lit in the same way, as an average tone.

meter will give a false low reading and the pictures will be overexposed. If there is no convenient patch of green vegetation from which to manually meter the reflected light, take an incident light reading by using either a separate hand-held meter or a homemade diffusion cap over the lens.

Alternatively, look around for gray rocks. If you practice this enough times where you can check your reading against a reading off grass, you will be able to predict with confidence what will work as a substitute medium tone.

Even if just a part of the frame includes an area of snow, this will affect a reflected light exposure. However, if you consider the composition in terms of tones, rather than colors, you should be able to select the correct exposure. For instance, if the proportion of green leaves and flowers to a background of snow is roughly equal, a matrix in-camera reflected reading will underexpose by approximately one stop. Therefore, if you use a manual mode and open up on this reading by one stop, the exposure will be quite acceptable.

To play it safe, it may be wise to bracket the exposures half a stop on each side as well. Therefore, if the in-camera reading is 1/30 of a second at f/11, you should use an exposure of either 1/15 of a second at f/11 or 1/30 of a second at f/8, and bracket half a stop on each side (1/15 of a second between f/11 and f/16, and 1/15 of a second between f/11 and f/8; or 1/30 of a second between f/8 and f/11, and 1/30 of a second between f/8 and f/5.6). If there is no wind blowing and you need as much depth of field as possible, it would be preferable to use 1/15 of a second at f/11 as the corrected exposure.

Problem Flowers

Achieving the correct exposure for some flower portraits can also be tricky. When metering with the camera, frame-filling

Rudbeckia "Marmalade" and *Amaranthus* "Hopi Red Dye," Kew Gardens, Surrey, England, July. *Hasselblad 500 C/M, 150mm f/4 Sonnar lens, Ektachrome 100S.*

Dark red flowers, especially with dark leaves, relect so little light that the camera will tend to compensate by overexposing. For this shot I used an incident light meter, although the framing meant that the area of yellow flowers, which reflect more light than an average tone, virtually compensated for a similar area of dark flowers and leaves.

close-ups of large white, yellow, or pastel-colored flowers will give false high readings and thus underexposed, gray images, unless the reflected readings are corrected. Alternatively, you can take an incident light reading and manually set the exposure. The same applies when photographing small, insignificant flowers with pale gray foliage. Conversely, dark red roses, black tulips, or any dark red leaves reflect very little light, and an automatic exposure will cause them to appear overexposed. Once again, either meter manually from green grass or measure the incident light.

Another metering technique that is appropriate for close-ups but not for landscapes is to use a Kodak gray card, which reflects 18 percent of the light and is equivalent to a medium tone. First select the flower and compose the picture, then place a gray card beside the flower, just outside the field of view so that you do not accidentally damage the specimen. Make sure that the card fills the entire frame, then meter the light reflected off it with the camera, preferably using a manual matrix mode. Kodak produces a pack with one 8×10-inch and two 4×5-inch cards. If you should need a larger area, simply attach two or more cards together using self-adhesive tape on the reverse white side.

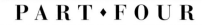
Lighting

Perfect blooms will not guarantee a perfect picture; the way they are lit when the shutter is released will play a major factor in the end result. When working outside, you have several options: You can go with the available light, modify it in some way, or pack up.

Anyone living in temperate regions will be aware that the length of daylight hours changes with the seasons. The quality of light also alters as the arc transcribed by the sun varies with the time of year. The length of time the sun appears above the horizon changes with latitude at the same time of year. For example, on June 15 at 40 degrees north latitude, the sun remains above the horizon for fifteen hours; this is reduced to twelve hours and seven minutes at the equator and extended to twenty-four hours at 70 degrees north latitude. In fact, at any time of year, the length of time the sun remains above the horizon at the equator remains constant. In the Southern Hemisphere, the longest day occurs in December, and in the Northern Hemisphere, in June.

Time of Day

When the sun is shining, the time of day greatly influences the quality of light. Most daylight color slide films are balanced to record authentic colors in summer sunlight when light has a color temperature of 5500 degrees Kelvin. Early and late in the day, when the sun is close to the horizon, the landscape becomes bathed in a warm cast as the color temperature drops to 2500 degrees K. Though such light is excellent for landscape photography, it will tend to create a false color cast to floral carpets. For this reason, and for those showy flowers that unfurl their petals only when bathed by sun, I prefer to wait a little while after first light. Conversely, for those flowers that open at dusk, such as many evening primroses, I either wait until the sun sinks below the horizon at the end of the day and use flash to photograph them or use natural light early the following morning. Even then, I may opt to use flash to spotlight a foreground flower while retaining the natural light on the landscape behind. A yellow cast can be reduced over the entire frame by using a pale blue cooldown filter in the Kodak Wratten 82 series.

At dawn and dusk there may be scope for silhouetting isolated larger architectural plants with simple leaves or branching patterns, such as yuccas and taller cacti. By metering the bright sky, you lose all trace of color and texture and thereby achieve a solid silhouette, which makes for a creative change of pace in a photo essay.

Many shades of green exist within the natural world, and these can change quite markedly with the time of day. When the

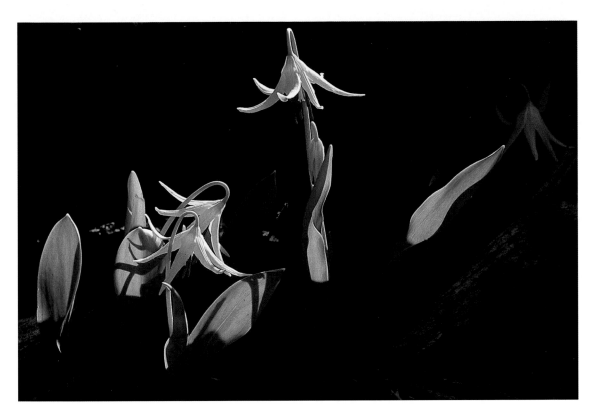

sun shines through fresh green leaves and grass, they appear as yellow-green; when lit by indirect light on an overcast day or shaded by trees, they have a distinct blue cast. This cold light can be reduced by using a warm slide film such as the Ektachrome SW series. Another solution is to use a straw-colored warm-up filter in the Kodak Wratten 81 series, which ranges from the palest 81 through 81A to 81EF. They all block blue light to varying degrees.

Diffuse Light

For much of the year, low-lying tropical locations are bathed in direct light, which may be great for landscapes but often is too harsh for flower photography. A gentler light is produced at times by a cloud cover, which functions like a vast diffuser, or by an overhead forest canopy, which casts shade on the floor below. Under these conditions,

Glacier lilies *(Erythronium grandiflorum),* Yellowstone National Park, Wyoming, June. *Nikon F4, 105mm AF f/2.8 Micro-Nikkor lens, Ektachrome 100 Plus.*

I spotted these glacier lilies, growing among burnt tree trunks felled by the 1988 fires, before the sun rose, so I had the camera set up ready for the first rays to backlight the flowers. For the correct exposure, I spot-metered the light through one of the green leaves.

shadows are no longer a problem, nor is the glare from sun shining directly onto shiny petals and leaves, and metering is much easier. Without wind, sharp images with long exposures are possible too.

The two thistle pictures on page 50 show the dramatic difference between direct sunlight one moment and diffuse light produced by a cloud passing over the sun the next.

Transparency films with well-saturated colors, such as Ektachrome 100S and Fuji Velvia, create colors that appear especially luminous in diffuse light. If you are prepared to get up early, flowers growing in wetland locations where mist pockets accumulate overnight can be photographed with an ephemeral misty backdrop. Low clouds enveloping high ground also present opportunities for taking pictures with an ethereal quality. Early-morning dew or a light rain shower can lend a special magic to flowers as they become decorated with diamondlike dewdrops.

Pink evening primrose *(Oenothera speciosa)* growing beside the road, Texas, April. *Nikon F4, 105mm AF f/2.8 Micro-Nikkor lens, Ektachrome 100S.*

Like many evening primrose flowers, these open at night, so they are best photographed early in the morning. A light cloud cover helps extend the time before the flowers begin to shrivel and also provides a soft, diffuse light for the delicate pastel tones.

For portraits of pastel-toned flowers, I prefer shadowless lighting. When faced with a cloudless sky, I create my own diffuse light by holding a white diffuser between the sun and the flowers.

Direct Light

A carpet of wildflowers beneath a blue sky with fluffy white clouds makes a striking landscape picture. Your main decision will be where to place the horizon in the frame.

With flowers at close range, you should be prepared to spend much more time appraising how the sun lights them, where the shadows fall, and not least, how the background is lit. For example, nothing can be more dramatic than backlit flowers viewed against a dark green or black background. All these factors will determine where to set up the camera in relation to the flowers. If possible, move around the flowers to appraise the optimum angle, considering the floral structure as well as the lighting. Plants lit from the front will rarely stand out, because the shadows fall behind the plant away from the camera, although the only way to illuminate deep-throated flowers, including some orchids, is from the front.

The shadows created by sidelighting, on the other hand, create a three-dimensional impression by casting shadows and adding depth to large flowers. If there is too much contrast between the sunlit and shadow areas, use a reflector or fill flash to light up

A yucca silhouetted against mountain ranges in Big Bend National Park, Texas, April. *Hasselblad 500 C/M, 150mm f/4 Sonnar lens, Ektachrome 64.*

Driving out of the park at the end of a long day, I spotted the yucca silhouette. Instinctively I pulled out my Hasselblad and placed the yucca at the side of the frame so that there would be plenty of space at the top for type to be superimposed. This picture illustrates how less can be more; by removing all traces of color and texture, attention becomes focused on shape alone.

49

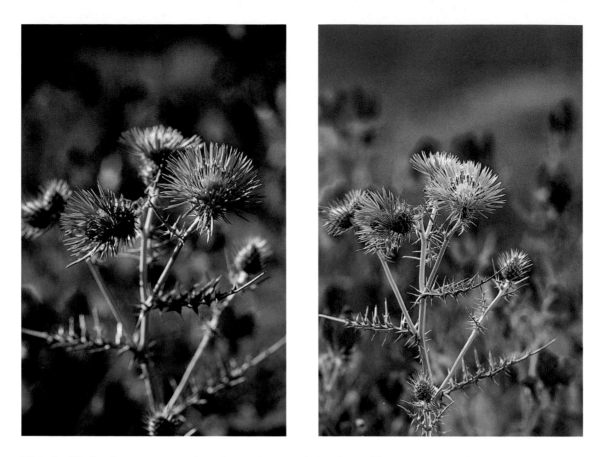

Thistle *(Galactites tomentosa)* and purple viper's bugloss *(Echium lycopsis),* southern Spain, April. *Nikon F4, 80–200mm AF f/2.8 Nikkor lens, Ektachrome 100 Plus.*
 This stunning purple duet was growing beside the road north of Malaga. After I had taken the backlit shot late in the day and walked to another clump of flowers, a cloud covered the sun, so I raced back to retake the shot bathed in soft, diffuse light.
 Above left: Backlit.
 Above right: Diffuse light.

the shadows. Sidelighting can greatly enhance the compositional element of plants growing out from a unitoned substrate, such as sand or snow, by repeating the shape as a shadow to one side (or in front of the plant if it is lit from behind).

Early or late in the day, when the sun is low in the sky, look for flowers that are backlit by the sun. Red poppies look especially vibrant when they are backlit; as the sun shines through flowers with translucent red or orange petals, they appear to glow. This is particularly noticeable with transparencies, which are viewed by transmitted light, whereas prints are viewed by reflected light. Backlighting also emphasizes spines on cacti and fine hairs on stems and leaves and repeats the shape of emergent aquatic plants in their reflections on the water.

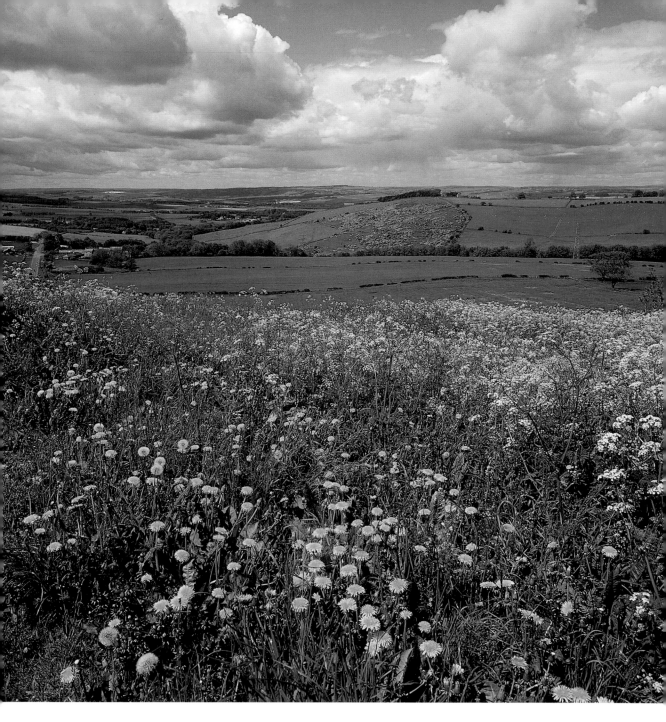

Meadow flowers: dandelions *(Taraxacum officinale)* and Queen Anne's lace *(Anthriscus sylvestris)*, Derwent Valley, Tyne and Wear, England, June. *Hasselblad 500 C/M, 60mm f/3.5 Distagon lens, Ektachrome 64.*

Even though the cloud formations were attractive, I decided the meadow flowers should occupy the greater part of the frame in this landscape, so I placed the horizon two-thirds up the medium-format frame.

Above left: Male sunshine or red cone bush *(Leucadendron discolor),* Cape Province, South Africa, September. *Nikkormat FTN, 80–200mm AF f/2.8 Nikkor lens, Kodachrome 25.*

South Africa is the natural home of many proteas, which are much prized by both gardeners and florists. In the Southern Hemisphere spring, the upper leaves of the aptly named sunshine bush turn yellow tinged with red inside, offsetting the red male flowers. The strong sidelighting accentuated the vibrant colors of this striking bush.

Above right: Ajo or desert lily *(Hesperocallis undulata),* Organ Pipe Cactus National Monument, Arizona, March. *Nikon F3, 35–70mm f/2.8 Nikkor lens, Kodachrome 25.*

As the sun rose, the shape of the lily was repeated by the shadow cast onto the desert floor. Rather than crop out the shadow, I decided to use it to lead the eye to the flowers.

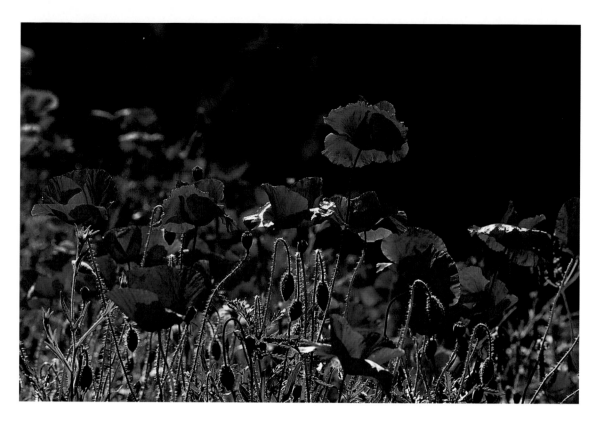

Getting the correct exposure for a backlit shot can be tricky using in-camera metering, however, especially if a large area of shadow lies within the frame. With red or orange petals, I will spot-meter the light passing through them and go with this reading. With yellow or pale-toned flowers, this will give an erroneous high TTL reading, so I either use a backlit green leaf or turn around 180 degrees and meter the light falling on green leaves or grass. If there are no green leaves, I use a hand-held light meter to record the incident light falling on the terrain behind me. When larger, bold-shaped, solid flowers such as tulips or large thistles are backlit, golden rim lighting defining their outline makes them stand out from the surroundings.

Even in dull weather it is still possible to take backlit flowers by using a flash. The only snag here is that unlike with sunlight,

Poppies *(Papaver rhoeas)*, southern Spain, April. *Nikon F4, 80–200mm AF f/2.8 Nikkor lens, Ektachrome Lumière 100.*

These red flowers with their large, translucent petals appear even more vibrant when they are backlit. I spent some time adjusting both the camera position and the focal length of the lens to compose both vertical and horizontal shots of the poppies. I used the camera's spot meter to gauge the exposure on the backlit petals.

you can only guess at the end result. To use a flash off the camera's hot shoe, you will need an extension sync lead. If you have a willing assistant, you can get him or her to hold the flash, but I much prefer to attach it to a ball and socket topped with a flash shoe on a pole that can be pushed into the ground. In this way, the angle of the flash

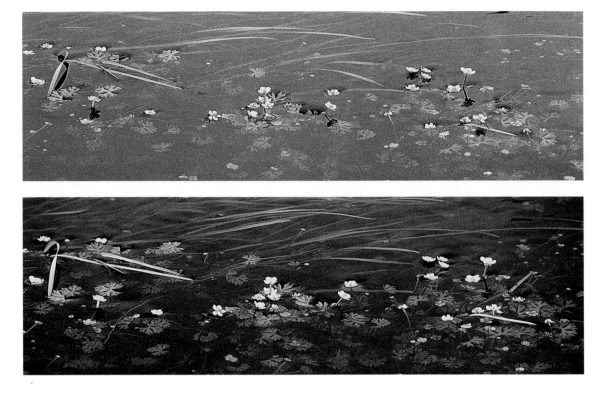

Yellow water buttercup *(Ranunculus* sp.*)*, Montana, June. *Nikon F4, 80–200mm AF f/2.8 Nikkor lens, Kodachrome 200 Professional.*

This pair of pictures shows how a polarizing filter can be used to eliminate the pale skylight reflection on water, thereby revealing more clearly the submerged leaves and buds of the aquatic plants. The medium-speed film was needed because the day was overcast and the plants were moving in the water currents.

Top: Without polarizing filter.

Bottom: With polarizing filter.

can be precisely lined up by looking along the line from the camera lens back toward the flash. The pole cannot be positioned directly behind the flower, or it will appear in the shot, but if it is angled in at approximately 45 degrees behind the flower from the left or the right, it will still produce a backlit effect. To create a narrow-angled beam, wrap a piece of black paper around the flash window to form a "snoot."

Initially, you should bracket your manual exposures. Be sure to note the film speed, magnification (if a macro shot), power of the flash, and flash-to-flower distance so that you can repeat a successful shot.

To reduce the likelihood of light falling directly on the lens, thereby causing flare to spoil the picture, always use a lens shade when taking a backlit picture. If it is not deep enough or you have forgotten to bring a shade, rest a piece of card or your hand on top of the lens.

Using Filters

The only way natural light falling on broad vistas can be modified before it is recorded on film is by means of filters. With close-ups, on the other hand, in addition to filters, natural light can be modified using

Striped coralroot *(Corallorhiza striata)*, Yellowstone National Park, Wyoming, June. *Nikon F4, 105mm AF f/2.8 Micro-Nikkor lens, Kodachrome 25 with reflector.*

When I discovered this orchid, it was spotlit on the left side by oblique early-morning light beneath trees. I used a reflector to fill in the shadows cast by the three-dimensional flowers onto the right side of the spike.

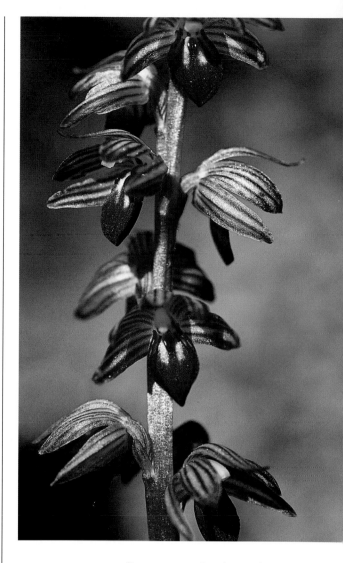

reflectors, diffusers, or flash. The light-balancing Kodak Wratten 81 (warm-up) and 82 (cool-down) filters were discussed in the section on Time of Day.

I find a polarizing (pola) filter particularly useful for flower photography. When standing with the sun to the left or right, it will increase the contrast between white clouds and blue sky for broad vistas with flowers in the landscape. It will also make tall-stemmed white lilies or daisies stand out more clearly by darkening a blue sky. In addition, a pola filter will remove skylight reflections from foliage in general and shiny leaves in particular. The net result is that the greens in a landscape or a close-up will appear much more saturated. The underwater foliage of aquatic plants is also greatly enhanced by using a pola filter, which removes distracting skylight reflections on the water surface and thereby reveals the submerged parts of the plants.

The simplest way to judge the effect of using a pola filter is to rotate it in front of the eye. While a pola filter clearly has many benefits, the downside is that if you fully polarize a scene, there will be a loss of one and a half stops of light. This can be a real problem if you are using slow-speed film such as Kodachrome 25 or Fuji Velvia (ISO 50) on a windy day, since the obligatory fast shutter speed (to prevent subject blur from moving plants) will not permit much depth of field with a slow-speed film. For this reason, it is preferable not to keep a pola filter

as a permanent fixture on the lens, but rather to use it with discretion.

Color slide film does not have the latitude to cope with the huge contrast between a colorless sky and the land below. When taking flowers in the landscape in such conditions, you have two options: crop out the sky or use a graduated (grad) filter to reduce the contrast. Grad filters have a gray, blue, magenta, or tobacco-colored strip along the top that fades into a clear area below. Each color is available in differ-

ent strengths. Even though blue is an authentic sky color, in overcast conditions it appears unnatural, so I prefer to use a gray grad. Square or rectangular grads that fit into a filter holder are more versatile than screw grad filters, because the depth of the color strip can be varied to suit each composition by sliding the filter up or down in the holder.

There is a whole galaxy of gimmicky filters, including starburst, rainbow, and multi-image, but they are totally inappropriate for documentary flower photography and don't contribute to original artistic interpretations either.

Reflectors and Diffusers

The two most useful accessories for photographing flowers at close range are a reflector and a diffuser, which are used to modify the quality of light falling on a small area. Reflectors are used to boost available light, to fill in harsh shadows, or to throw light onto a subject completely in shadow. Ready-made circular, collapsible reflectors are available in various finishes, including silver, gold, and a mixture of gold and silver. The mixture gives the most natural light for white and pale-toned flowers. Homemade reflectors can be made from a host of shiny objects, including aluminum foil or a silver survival blanket, although the foil needs to be wrapped around a piece of card and the blanket held by

Bull thistle *(Cirsium horridulum)*, Texas, April. *Hasselblad 500 C/M, 80mm f/2.8 Planar lens + 1.0 Proxar (close-up) lens, Ektachrome 100S with diffuser.*

I found this magnificent thistle bathed in early-morning light, which cast strong shadows among the leaves. To simplify the image, I diffused the direct rays of the sun with a white diffuser. This resulted in a loss of two stops of light.

someone to prevent them from flapping in the breeze.

When working in a forest, shafts of sunlight beaming down through the overhead canopy constantly move as the sun passes overhead. One moment a flower is spotlit; the next it is blanketed in shadow. Here a reflector can be used to precisely direct the sunlight onto a flower.

Diffusers function like miniature clouds, softening direct sunlight and, depending on their thickness, reducing the shadows or eliminating them altogether. They can be used to reduce highlights on shiny fruits, but they are most useful for reducing extremes of light and shadow to produce lighting that is more restful to the eyes, especially for flowers that are highly three-dimensional or pastel-toned.

Like reflectors, ready-made collapsible diffusers are available in various sizes, and the smaller versions can be held easily in one hand. White muslin or thick tracing paper stretched over an opened out metal coat hanger can make an inexpensive but effective homemade substitute.

Flash

A flash is essential for photographing nocturnal flowers, such as the larger cacti that open at night. In this case, it is the sole light source, and even though it won't light up the background, a black backdrop doesn't appear out of place for a night bloomer.

When choosing a flash, preferably select a dedicated model, and one where you can vary the amount of power. Also, don't forget a sync lead for using the flash off the hot shoe.

As with direct sunlight, a naked flash head will create harsh highlights on shiny leaves or fruits. The solution is to soften the flash either by fitting over the flash window a diffuser (such as a Sto-Fen Omni Bounce, which resembles a white lid of a slide box, or white translucent trace gel made by Rosco) or by bouncing it off a white, angled

Clerodendrum indicum at Fairchild Botanical Garden, Miami, Florida, December. *Nikon F4, 80–200mm AF f/2.8 Nikkor lens, Ektachrome 100 Plus, with Nikon SB24 used as fill flash.*
 When faced with a strong overhead sun casting a shadow on the underside of horizontal branches, flash can be used as a fill-in. By keeping the available light exposure constant and underexposing the flash by one and a half stops, the sky color is unchanged while the true color of the plant is portrayed. The direct flash, however, resulted in reflections appearing in the shiny black fruits surrounded by the persistent swollen red calyx stars.

reflector. Provided the diffuser doesn't hide the sensor in the flash unit, TTL units will meter the light and quench it automatically when the subject has received enough light.

When first introduced, the ring flash, which encircles the lens, seemed to be an invaluable aid to flower photography, but the front lighting is uncreative and can introduce additional problems with reflective petals and fruits. It is useful, however, for throwing light down into deep-throated flowers.

Fill Flash

Not so many years ago, I used flash for photographing flowers only when taking a nocturnal flower or when working in a dark forest. I resisted using it out in the open by day, for I disliked the way the flash gave my pictures a black, nocturnal-looking background. That was before dedicated TTL flash units that meter off the film plane became available. These revolutionized the fill-flash technique to such an extent that I

Bluebells *(Hyacinthoides non-scripta)* in the Conservation Area, Kew Gardens, Surrey, England, May. *Hasselblad 500 C/M, 150mm f/4 Sonnar lens, Ektachrome 100 Plus.*

One of the glories of an English spring is discovering an azure carpet of bluebells on a woodland floor. Yet, often the true blue color appears on slide film as a disappointing mauve. Here, shadows cast over most of the flowers have helped increase the intensity of the blue. In this case, using a pale blue filter was not an option, as it would have affected the color of the fresh green leaves on the oak tree.

now regard flash as an invaluable tool for my flower photography, and I wouldn't go anywhere without one.

Like a reflector, a flash can be used to fill in shadows or illuminate recessed parts of a flower. Without a dedicated TTL flash unit, I had to calculate where to position the flash relative to the subject, but now taking a fill-flash shot is just a question of using the available light exposure, plugging in the flash, and underexposing it by one and a half to one and two-thirds stops. The beauty of a dedicated TTL flash, such as a Nikon SB26, is that one moment it can be used to push light into a deep-throated flower, the next to fill in shadows high up on flowers or fruits of trees lit by an overhead tropical sun. The great advantage of using this technique is that it doesn't appear obviously flash-lit. Also, if the camera shutter is released too quickly after the previous shot, before the flash has had time to recharge, the picture will not be completely useless, because the daylight exposure is retained.

Photographing Blue Flowers

Fortunately for photographers, the stunning color of blue lupines and delphiniums is reproduced on slide films as we remember them. Sadly, this is not the case with many other blue flowers, for which it is notoriously difficult to record the true blues—as we see them—on transparency film. The azure carpets of bluebells that enliven many British woodlands in spring often come out with a disappointing pink tinge, and the intense blue trumpets of morning glory flowers invariably appear as a distinct shade of mauve. The reason why many blue flowers are a problem is that they also reflect far red and infrared wavelengths that we cannot see but that many transparency films record.

There are various ways of counteracting this anomaly. First, try to photograph the flowers shortly after they have opened, as the shift to the pink or mauve part of the spectrum increases with the age of the flower. Second, since overcast natural light produces a blue cast, it helps to wait for a cloud to cover the sun when photographing blue flowers en masse. When taking close-ups on a sunny day, a diffuser can be used to produce a localized colder light.

A pale blue color-correcting filter such as a Wratten 20CCB will enhance blue petals, as will a filter in the Wratten 82 cool-down series, although either will also tend to make any green stems or leaves appear distinctly blue-green.

Natural Vision:
A Heather Angel Portfolio

The pictures in this section have been selected to stand on their own, regardless of the techniques used to achieve the end result. I have included some of my all-time favorites, which date back a decade or more; others are barely out of the camera. Most have been taken while working on my own, for much of my photography is done in isolation so that I can channel all my thoughts into appraising the composition and the lighting, without being distracted by other people.

When taking massed flowers, you must often wait for lulls to occur in seemingly persistent wind or a shaft of sunlight to break through cloud cover. I find that the more time I am prepared to invest out in the field, the greater my chances of finding a choice specimen in an attractive setting, thereby increasing the odds of getting a memorable picture. But there are days when even the best laid plans go awry. The light is so poor or the wind so persistent that it is pointless to waste film on shots that will end up in the trash. When I have invested time in traveling some distance, however, I tend to be more inventive about my photography than on those occasions when I just hopped in the car and drove down a local lane.

Take, for example, the time I learned that a day's trek in search of the Fjordland crested penguin in the Westland area of New Zealand's South Island had been canceled. I had no option but to turn around and make the five-hour drive back to base, but the nagging thought of a completely wasted day

Russell lupins near Lake Tekapo on New Zealand's South Island, early in December. *Nikon F4, 80–200mm AF f/2.8 lens, Ektachrome Lumière 100 rated at ISO 1600.*

An impressionist interpretation was achieved by slightly moving the camera before making each of the thirty exposures on a single frame.

inspired me to make a detour to check out multicolored lupins around Lake Tekapo.

They were in perfect condition. Instinctively, I began by taking sharply focused shots. Then I decided to experiment by taking multiple exposures on a single frame in an attempt to achieve a Monet-like impression of the colored spikes. Often I had taken three or four exposures of a bud opening on a single frame, but never before had I tried thirty exposures on one frame. Using ISO 100 film rated at ISO 1600, I framed a group of flowers with distinct blocks of color and waited for a period of unchanging light. Before exposing each frame, I set the multiple-exposure lever to prevent the film from advancing to the next frame. After each shot, I slightly adjusted the framing, but not the focus.

A big advantage of this technique is that the fast shutter speeds used (even on a dull day) make it possible to skip the tripod and hand-hold the camera, although in this case I kept the camera on the tripod. If I am running short of film, this time-consuming technique is also a good way of economizing on film.

Since I took the lupins I have taken many more multi-exposure shots, but none of them match the first. Now I realize I was lucky to have selected a frame with bold blocks of color and a dark backdrop. Small areas of color set against a green background have much less impact. Also, white flowers should be avoided, as they tend to be far too conspicuous.

Kashmir comes high on my list of floral paradises; it is a great tragedy that the political unrest in recent years has made this an unsafe area for foreign visitors. I can still recall the exciting botanical pony trek I made there back in 1974. We set off from Sonamarg on ponies that knew every inch of the route, but we had to dismount to negotiate boulder-strewn riverbeds. Sitting high in the saddle provides an excellent vantage point for spotting choice alpines, although I soon learned not to pull up beside a photogenic clump, because my pony would invariably begin to munch its way through the flowers before I had dismounted. We also had to contend with flocks of sheep and goats reaching choice areas before we did.

After trekking for several days, we climbed up a knoll beside a glacial lake to feast our eyes on an isolated clump of white aquilegia flowers—an idyllic situation plus perfect blooms. I could hardly believe my luck. Instinctively, I reached for a 35mm lens so I could include some of the lake behind the flowers. It took me a little while to find a viewpoint from which I could isolate the white flowers against the blue glacial water. The situation allowed me to compose both vertical and horizontal frames, although I prefer the vertical format reproduced here.

Aquilegia fragrans isolated against the blue water of a glacial lake at an elevation of 13,100 feet, Kashmir, July. *Nikkormat FTN, 35mm f/2.8 lens, Kodachrome 25.*

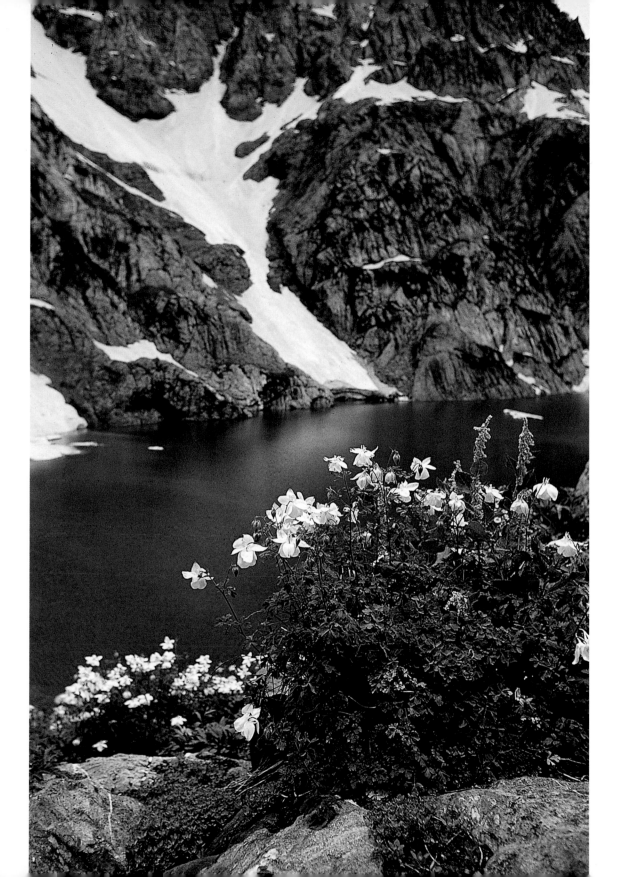

The advantage of being prepared to travel around the world in search of flowers is that your photography no longer has to be condensed into a brief time span. Every month of the year presents floral photo opportunities.

Flying to the Falkland Islands early in December to join a ship gave me the opportunity to spend a few days photographing the flowers in the austral spring. As we island-hopped in a small airplane, the most striking aspect of the treeless landscape was expansive areas of yellow. A closer inspection down on the ground revealed them to be flowering gorse bushes—a familiar thorny shrub of British heathlands that was introduced to the Falkland Islands by British settlers.

Before visiting these islands I would never have believed that gorse would be a contender for a graphic picture. But then, I had never seen gorse with a mantle of yellow flowers that completely obliterated any trace of the dark green stems. Constant

Gorse *(Ulex europaeus)* flowering in early December, Falkland Islands, with new spring growth beginning to appear. *Nikon F4, 105mm AF f/2.8 Micro-Nikkor lens, Ektachrome 100S.*

pruning by wind and salt spray in the exposed Falkland Islands environment keeps the green branches in check, so that when the flowers open the effect is dramatic, and the yellow cloaks make a perfect contrast to the fresh green shoots.

At close range, the coconutlike smell of the gorse flowers is quite heady and certainly reminiscent of a bluebonnet field—not surprising, as both plants belong to the pea family.

The frame-filling yellow flowers gave a much brighter than average in-camera reflected reading, so for all the shots—both wider angles and this close-up—I manually metered the light off the green pasture where I stood.

March and April are productive months for flowers in the Mediterranean, although truly spectacular displays of wildflowers along roadsides and in fields are dependent on rain falling at the right time. In the latter part of April, I was particularly attracted by striking color combinations in southern Spain. How infinitely more attractive is the casual intertwining of the purple and yellow flowers lit by a soft evening light than the serried ranks of the vines behind.

Purple viper's bugloss *(Echium lycopsis)* with a yellow crucifer on roadside, southern Spain, April. *Nikon F4, 80–200mm AF f/2.8 Nikkor lens, Ektachrome 100 Plus.*

Without green leaves or leaflike stems, flowering plants are unable to photosynthesize their food. Instead, some species live as parasites, tapping food reserves of a host plant. Bladder cytinus lives on the woody-stemmed cistus shrubs, which are a characteristic member of the Mediterranean garigue plant association. Although I had seen the yellow flowers nestling in their red bracts many years before, what attracted me here was the color contrast between the opened flowers and the adjacent unopened buds nestling in among the dry leaf litter.

Elation rapidly turned to frustration when I noticed an obvious shadow from a high branch falling right across the flowers. As I had an airplane to catch, I could not return later in the day. Fortunately, I had some string with me and was able to tie back the branch so that the bladder cytinus was evenly lit.

Bladder cytinus *(Cytinus hypocistis),* a parasitic plant related to the outsize tropical rafflesia, southern Spain, April. *Nikon F4, 105mm AF f/2.8 Micro-Nikkor lens, Ektachrome 100 Plus.*

Being in the Himalayas or the mountains of China when the rhododendrons are in flower is a rewarding experience. The wealth of blooms on the larger, treelike species is quite awesome. The burans study taken near Mussoorie was among the many hundreds of subjects I took during a month-long commission by the British Council in Delhi to document the biodiversity of the Himalayas. It was chosen as the cover picture of a book compilation of scientific papers.

What could be more idyllic than taking the red blossoms offset against the snow-capped Himalayas? Yet this picture is only a partial truth; it does not tell the story of man's impact on this unique, mega-diverse region. In another shot, I kept the rhododendron at one side of the frame and angled the camera down onto the hillsides. This tree, plus a few others, were all that remained of the native forest, which had been clear-cut so that the hillsides could be terraced for planting crops. Thus the camera angle and the lens you select can make a huge difference in the information a picture imparts to a viewer.

Burans *(Rhododendron arboreum)* in flower, Mussoorie, Uttar Pradesh, in early April, with snow-capped Himalayas behind. *Nikon F4, 35–70mm AF f/2.8 lens, Ektachrome 100 Plus.*

The philosophy that less can be more is nowhere more applicable than when looking at a photograph. What could be simpler than an image of a bud breaking to reveal a tantalizing glimpse of color of still-furled petals? During this short-lived stage, we can delight in the economic shape and form of the bud and anticipate the glories yet to come.

The yellow flag iris was a chance encounter made while walking along a towpath beside a canal in search of waterbirds. Even though I was set up with a long lens, it didn't take me long to switch to a macro lens. The elongated bud was a natural for a vertical composition, which I placed off-center in the frame.

White and cream flowers are among the most difficult to photograph; for one thing, getting the correct exposure using a reflected in-camera reading can be tricky.

The scent of michelia flowers, a relative of magnolia, is so potent that I smelled the blooms long before I saw them. Most were high up on a tree, and the best accessible flower had a bright background. I knew I had to decrease the contrast of the flower in shade and the sunny backdrop, so I decided to use fill flash to push some light into the flower. Using the daylight exposure, I underexposed the flash by two stops.

Michelia doltsopa flower at the Huntingdon Botanic Garden, California, February. *Nikon F4, AF 80–200mm f/2.8 lens, Ektachrome Lumière 100 with Nikon SB24 used as fill flash.*

Yellow flag *(Iris pseudacorus)* bud, Hampshire, England, June. *Nikon F4, 105mm f/2.8 Micro-Nikkor lens, Ektachrome 100S.*

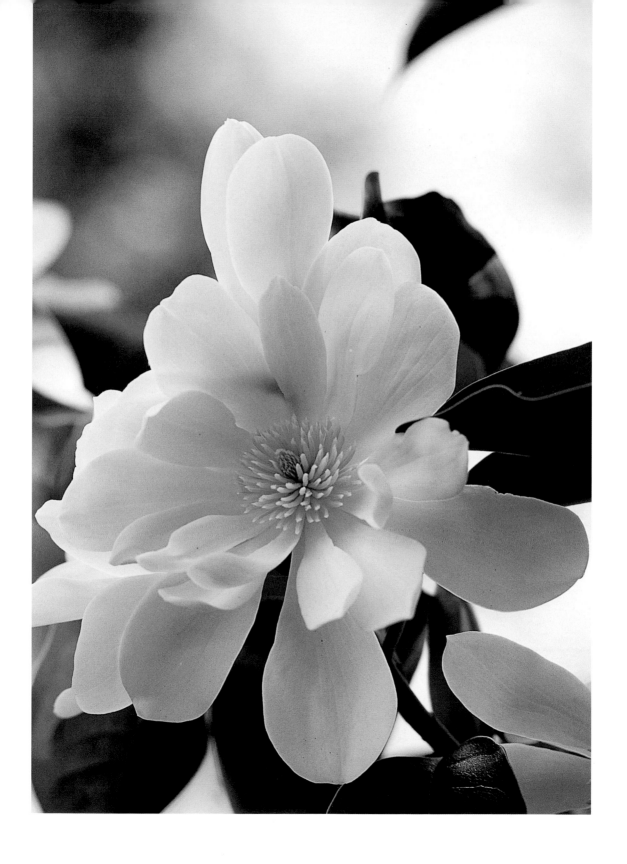

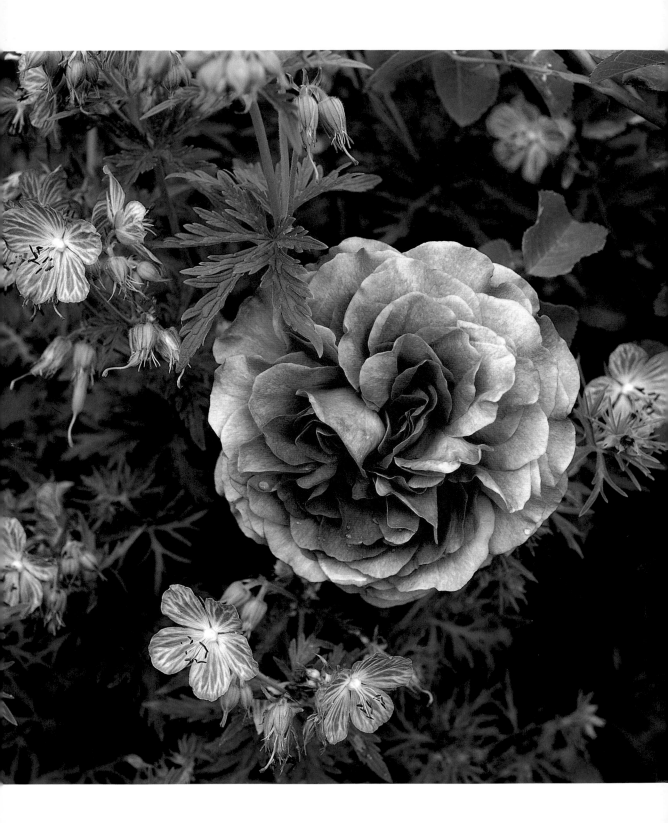

Whenever I visit British gardens, I am constantly on the lookout for eye-catching cameos such as this, which have great appeal as cards. The sun was shining when I first saw the shot, so I set up and waited for a cloud to produce the soft, diffuse light I wanted for the convoluted rose petals. The delicate mauve geranium flowers enhance the composition without detracting from the shape and color of the rose itself.

A 6-foot-tall titan arum *(Amorphophallus titanum)* flower portrayed against a misty backdrop under glass at the Kew Gardens, London, England, August. *Nikon F4, 80–200mm AF f/2.8 lens, Ektachrome Lumière 100.*

The Royal Botanic Gardens, Kew, which border London's River Thames, are a mecca not only for botanists, but also for plant photographers and artists, with some thirty-eight thousand different kinds of plants growing both out in the open and under glass within the 300-acre site.

Among the most bizarre plants I have photographed anywhere was the 6-foot-tall giant titan arum. When it flowered inside a tropical glasshouse in 1996 for the first time in over thirty years, it attracted worldwide media attention. Having taken conventional shots of this giant among flowers, which is also known as devil's tongue or corpse flower (for the fetid smell it produces to attract pollinators), I wanted to convey the humid rainforest environment. Automatic misting sprays that repeatedly charged the air during an early-morning visit provided an appropriate mystical atmospheric backdrop.

Left: Rosa "Warwick Castle" and *Geranium pratense* "Mrs Kendall Clark" in private garden in Sussex, England, June. *Hasselblad 500 C/M, 150mm f/4 Sonnar lens with 1.0 Proxar (close-up) lens, Ektachrome 100 Plus.*

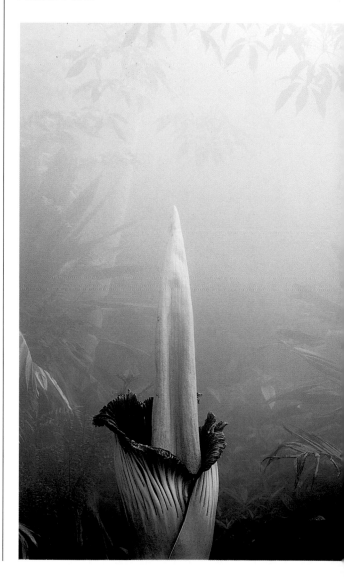

One way of producing a creative interpretation of flowers, instead of a straight record, is by making an image-transfer print from a color slide. This is copied onto color Polaroid print film using a Vivitar Instant Slide Printer. After only ten seconds, the Polaroid print is peeled apart as the red layer is beginning to appear. The print is discarded, and the negative backing paper is placed facedown onto art paper. Pressure is applied to the back of the negative using an ink roller, then the backing paper is carefully peeled away, leaving the image of the transfer print on the art paper.

This can be a tricky process, but I was lucky when the print of the poppies (copied onto slide film for reproduction here) worked the first time. I later found that any pictures with large, dark areas tend to lift off with the backing paper.

An original conventional slide of backlit corn poppies (Papaver rhoeas) *has been transformed into an artistic interpretation by using the image-transfer technique. The original slide was copied onto Polaroid film to create an image from the backing paper on art paper. This technique is an excellent way to produce new images of flowers, even in winter.*

Composition

Selecting which flower, or flowers, to photograph is the initial stage in a series of events that leads to the production of either a straight documentary approach or an interpretation of the subject as we visualize it. After finding photogenic flowers, many factors play a part in achieving the final image: choice of format, focal length of lens, film type, aperture, shutter speed, and lighting. Even when all these variables have been selected, where you decide to place the limits of the rectangular (or square) frame will affect the final composition. More than once I have been amazed at the variations achieved by a group of photographers working side by side.

The good thing about flowers is that, unlike animals, they are fixed and won't get up and run away. Therefore, unless you are working in a forest punctuated by ever-changing shafts of light, you have plenty of time to appraise the lighting and select the best camera angle. Sadly, all too often insufficient time and thought are given to producing a memorable composition.

When I began taking photographs of wildflowers, I knew of only two approaches: flowers in their habitat and close-ups. In those days, the demand was for documentary-type records of what we saw. Large clumps of flowers or massed carpets of one or two species, such as golden poppies in

California deserts or azure carpets of bluebells in British woodlands, were commonly taken as broad views, showing the plants in their landscape. Then there were the tightly cropped close-ups that appeared crammed onto a single page of a magazine or book to aid identification of flowers in the field or in the garden. Scope for varying the lighting and composition is very limited for such photos, since the flowers need to be evenly lit without any harsh shadows.

As my photography developed, I learned to automatically scan the viewfinder to check that there were no out-of-focus foreground stems or leaves that would distract the eye away from the main subject, although sometimes these may contribute to the composition. Distant telegraph poles, wires, or jet trails in the sky also can spoil a picture.

By considering all the elements of the composition more carefully, I came to realize it was possible to inform the viewer in a creative way. Light and shadow can play a big part in producing more creative compositions. Take, for example, a simple flower emerging from an even-toned substrate such as a sand dune; if the flower is lit by low-angled sunlight early or late in the day, the shadow it casts can form a striking element in the composition (see page 52). Reflections of larger flowers growing beside water

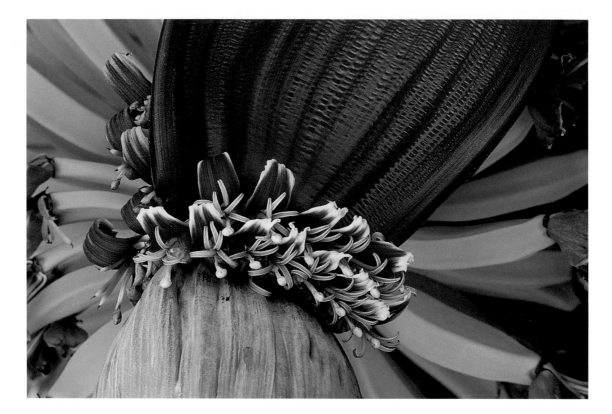

Banana *(Musa sp.)* flowers, Morocco, September. *Nikon F4, 80–200mm AF f/2.8 Nikkor lens with extension tube, Ektachrome Lumière 100.*

Over the years I have taken many pictures of bananas, but I had never looked twice at their flowers before a visit to Morocco. While panning the camera with a long lens following a bird, I momentarily alighted on a banana flower. I was intrigued by the juxtaposition of the shapes and colors and settled for this tight crop on the flowers and the young green bananas behind.

or even emerging from water can add an attractive element.

How you compose your photograph depends to a large degree on what kind of image you wish to produce and the information you want to impart to the viewer. When we first set eyes on a mass of flowers in the landscape, instinctively we see *the* shot and select the appropriate lens. Then all our thoughts and energy are channeled into composing and taking a single picture. All too often—and I was guilty of this—we take down the tripod and move on, looking for a new subject. If the light is good, however, it may be infinitely more profitable to stay put and work the scene for all it is worth.

Instead of wasting precious time walking or driving to another viewpoint, give yourself an assignment to push the setting to the limit. Many a time I have stopped for a specific shot, only to find enough material to keep me working for several hours. To date, my record is six hours in a Texas field on private property, where ancient oaks and mesquite trees with fresh green leaves rose up from a multicolored carpet of red (phlox), yellow (coreopsis), and blue (bluebonnets).

Maximize the opportunities by varying the camera angle (try shooting lower or higher than the original shot) or by changing the focal length of the lens. Do more than just slap on a macro lens for a close-up after taking a wide-angle view. This is not stretching your ability to achieve varied compositions from a single scene.

To illustrate this point, I have chosen three shots from the Texas field (see pages 80 and 81). Notice how I have varied the scale of the

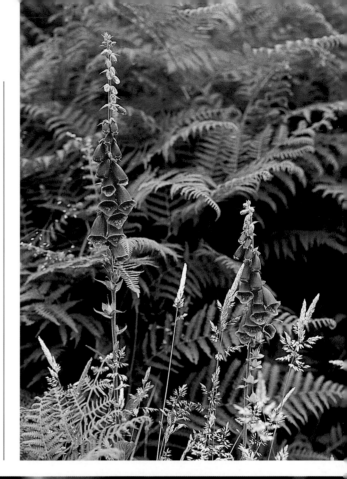

Foxgloves *(Digitalis purpurea)*, Hampshire, England, June. *Nikon F4, 105mm AF f/2.8 Nikkor lens, Ektachrome 100 Plus.*

Right: Tall flower spikes immediately suggest a vertical format, and this was the way I framed my first shot.

Below: Then I realized that by getting in closer with a slight change of camera angle, there was also a horizontal picture to be taken. In both cases, the color of the flowers contrasts well against the green bracken.

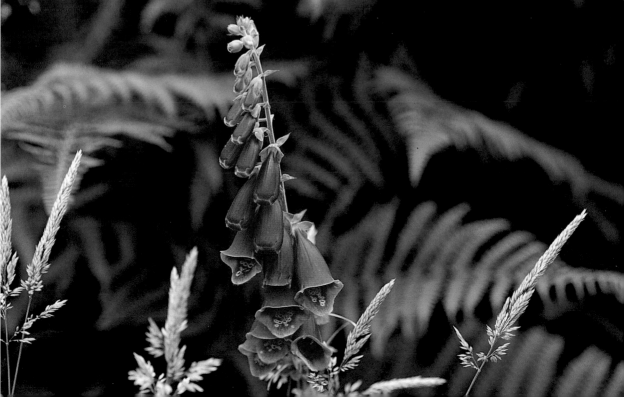

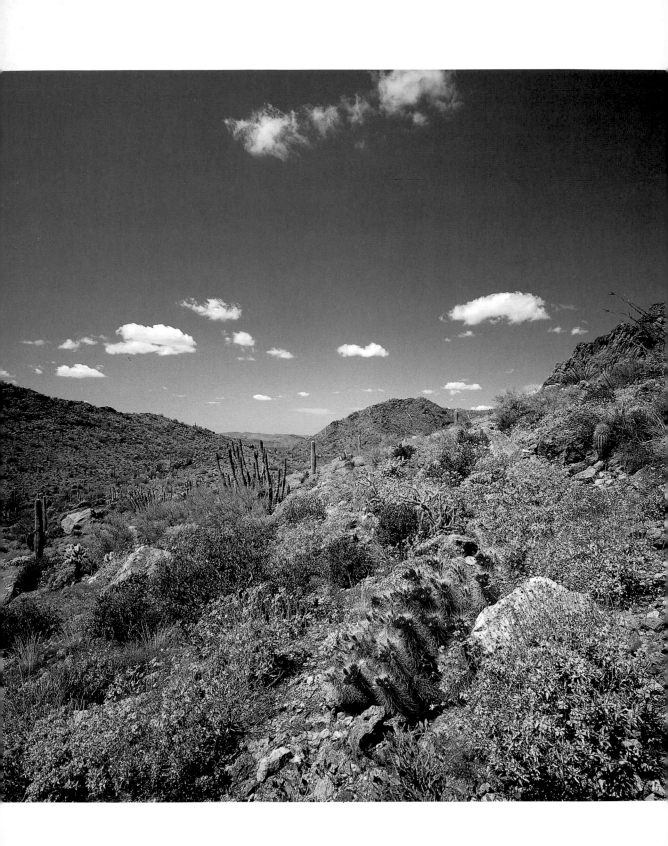

Hedgehog cactus *(Echinocereus engelmannii)* among perennial brittlebush *(Encelia farinosa),* Organ Pipe National Monument, Arizona, March. *Hasselblad 500 C/M, 60mm f/3.5 Distagon lens, Ektachrome 64.*

The red flowers of the hedgehog cactus caught my eye among the almost continuous yellow cover of brittlebush plants. With this plant as a focal point, I used a wide angle of view to include the surrounding desert landscape.

scene by using different lenses and camera angles. Each shot emphasizes a different facet, but together they reveal more of the stunning location. For me, the best shot came right at the end of an overcast day, after I had packed up my gear. As soon as I saw the sun break through to spotlight the flowers in contrast to the somber ancient oak, it was a race against time. I took all the shots in this field while standing on a small stepladder, which not only gave me an elevated viewpoint, but also avoided excessive trampling whenever I stopped to photograph.

Selecting the Viewpoint

Apart from trees, climbers, and columnar cacti, relatively few plants produce their flowers conveniently at eye level, so taking close-ups usually means being prepared to get down to their level by crouching or even lying prone.

By using a low viewpoint and a wide-angle lens, it is possible to depict the plant at one side of the frame and to show the habitat behind. This works particularly well for alpine plants with brightly colored flowers that naturally separate from their background. White or insignificant flowers, on the other hand, may require a different strategy. Flowers sprouting from the tips of branches and tall-stemmed white flowers such as oxeye daisies, lilies, and bear grass can be isolated very successfully against a

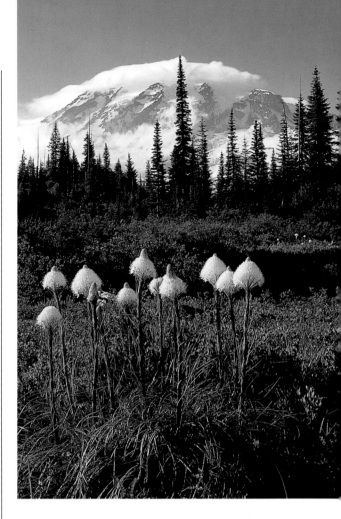

Bear grass *(Xerophyllum tenax),* Mount Rainier National Park, Washington, July. *Nikon F3, 80–200mm AF f/2.8 Nikkor lens, Kodachrome 25.*

On a day when a clear sky revealed snow-capped Mount Rainier, I channeled all my energies into taking landscapes. At one point, I discovered this clump of bear grass, which could be positioned in the foreground to echo the mountain behind.

blue sky by using a low camera angle. A wide-angle lens can be used from such a viewpoint to obtain graphic images of the large nocturnal flowers produced by the columnar saguaro cacti in Arizona and farther south.

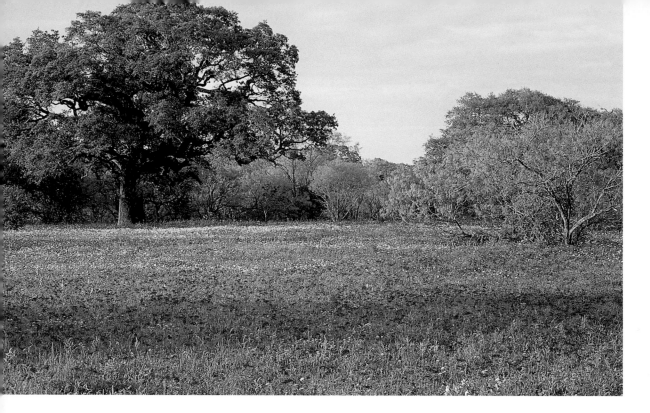

Top: Nikon F4, 20–35mm AF f/2.8 lens, Ektachrome 100S.
Bottom: Nikon F4, 80–200mm AF f/2.8 lens, Ektachrome 100S.
Opposite page: Hasselblad 500 C/M, 150mm f/4 Sonnar lens, Ektachrome 100S.

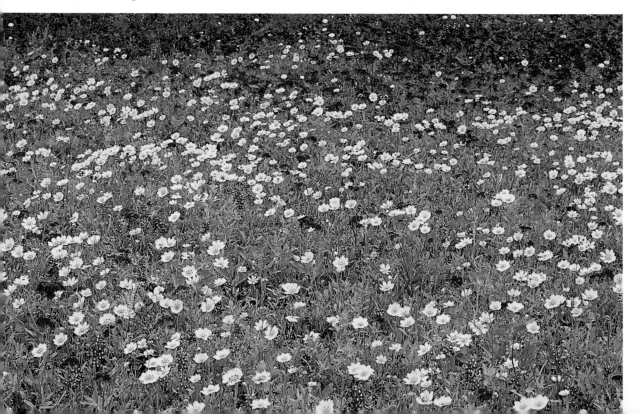

Wildflower display near Cuero, Texas, April.

The kaleidoscope of colors formed chiefly from red phlox, coreopsis daisies, and bluebonnets in this floriferous field gave me enough material to work with different cameras and lenses non-stop for six hours. With overcast conditions for most of that time, I chose a film that would nonetheless produce well-saturated colors. Another shot taken in this field appears on the front cover. Just when I thought it was all over, the sun came out to throw an evening glow on the field. Who says there are no thrills in flower photography?

Top left: Daisy *(Didelta tomentosa)* on Blou-bergstrand sand dunes, The Cape, South Africa, September. *Hasselblad 500 C/M, 60mm f/3.5 Distagon lens, Ektachrome 64.*

A low camera angle with a wide-angle lens enabled me to show the dune habitat of this impressive daisy plant. It also revealed the geographic location with the distinct profile of Table Mountain in the distance.

Walnut *(Juglans regia)* catkins, southern Spain, April. *Nikon F4, 80–200mm AF f/2.8 Nikkor lens, Ektachrome Lumière 100.*

Walnut trees leaf out with striking but sadly ephemeral bronze leaves. After eyeing trees growing beside the road for a couple of days, I finally found one with an uncluttered branch. I isolated this clump of catkins against a meadow by throwing it out of focus. It was pure luck that the color of the background echoed the catkin color.

Inaccessible flowers growing in the middle of a large lake or high up trees may require a telephoto lens in order to achieve a reasonable image size. Erect flowers such as those of magnolias, the Indian bean tree, and the horse chestnut can be isolated against a blue sky, enhanced by a polarizing filter. On the other hand, pendulous catkins near the end of a branch can be isolated against out-of-focus vegetation.

In a flat landscape, gaining even a few feet in height can change the perspective quite dramatically. For this reason, I am always on the lookout for a hill or a bridge from which to look down upon massed flowers in the landscape. I have had a roof rack built onto my four-wheel-drive Subaru utility vehicle to provide a convenient, mobile elevated view. When working abroad, I often use a lightweight stepladder for gaining extra height to look down upon a mass of short-stemmed flowers. Once, when faced with a high stone wall enclosing wildflowers inside a small preserve, I

Part of rose border in Llanllyr, a private garden in Wales, June. *Fuji GX617 panoramic camera with 105mm f/8 lens, Ektachrome 100 Plus.*

Familiarity with a landscape or, in this case, a garden can help you decide how to tackle a problem. Here, using an ultra-wide-angle lens on a conventional camera simply increased the area of sky and gravel path. For a return visit, I rented a panoramic camera (which takes four 6×17cm exposures on a 120 roll or eight on a 220 roll) and borrowed a stepladder to do justice to this glorious midsummer scene.

resorted to standing on a rigid ice chest to get the picture I wanted.

A higher viewpoint improves the effect of massed flowers, whether growing in the wild or in a long garden border, by increasing the area of color within the frame. A backdrop of green trees can effectively draw the eye toward the colors. Alternatively, a

Fireweed *(Chamaenerion angustifolium)* on a roadside, Tyne and Wear, England, July. *Hasselblad 500 C/M, 60mm f/3.5 Distagon lens, Ektachrome 100.*

While I was driving along country lanes, this large stand of fireweed caught my eye. I climbed with my tripod onto a custom-made boarded-in roof rack on my four-wheel-drive to get a view of the countryside beyond. The patchwork of fields bordered by hedgerows is typical of the way lowland Britain is farmed. The cloud formation was perfect—not so obvious that it dominated the picture but a great bonus for breaking up the large expanse of blue sky. I selected an exposure that gave me an aperture of f/11 to ensure sufficient depth of field to get everything from the fireweed to the distant hills in focus.

Flowers of powderpuff tree or hippo apple *(Barringtonia racemosa)*, Kew Gardens, Surrey, England. *Nikon F4, 80–200mm AF f/2.8 Nikkor lens, Ektachrome Lumière 100.*

By using a medium-length lens and not stopping it down beyond f/8, I gained enough depth of field to render the staminate flowers in focus against an out-of-focus background.

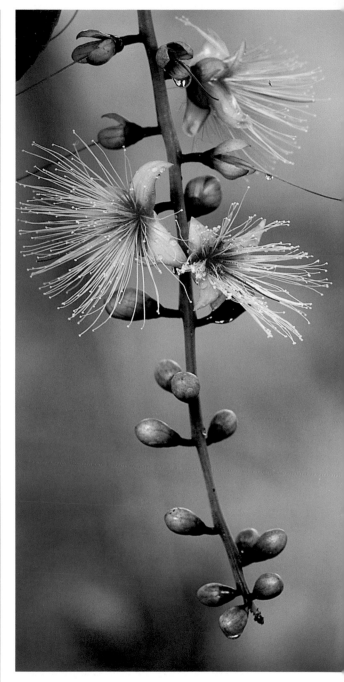

tight crop without any hint of background can be compelling. Large blocks of color also lend themselves to a panoramic format. I use a Fuji GX617 panoramic camera, which takes 120 roll film and produces just four 6×17cm frames. If big enlargements are not required, much more economical ways of gaining a panoramic format are to crop a horizontal 35mm frame with a strip of unexposed film or to use the panoramic crop on an APS camera. An elevated viewpoint allows the camera to look down onto the flower heads to ensure maximum depth of field. Alternatively, use one of the Canon TS-E lenses that have both tilt and shift functions.

Plants that bear individual radially symmetrical flowers are best taken with the film plane parallel to the flower head—horizontal for blooms that face the sky and vertical for flowers that hang their heads, such as sunflowers. An erect spike bearing many small flowers, such as fireweed or pickerelweed, needs to be taken from the side. With cushion-forming plants that hug the ground, you can take overhead views of the repetitive pattern.

Depth of Field and Hyperfocal Distance

Whenever you focus a lens on flowers with a wide-open aperture, they will appear crisp in a single plane and out of focus on either side of that plane (see page 107). More of the scene can be brought into focus by stopping down the lens to successively smaller apertures, from f/2.8 to f/4, to f/5.6, to f/8, and so on. Generally, the depth of field increases on both sides of the original

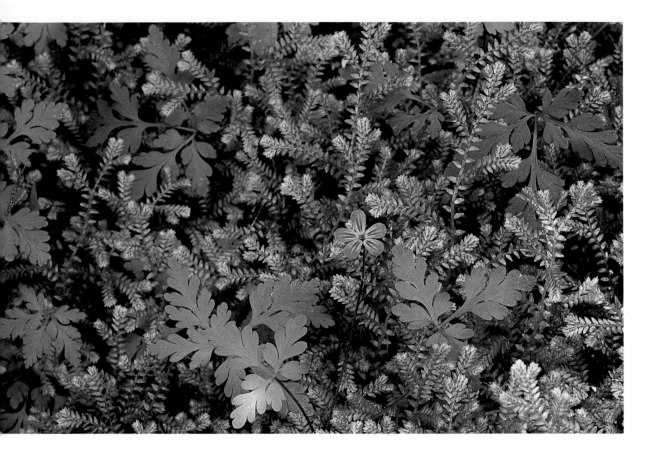

Herb Robert *(Geranium robertianum)* with club moss, north of Auckland, New Zealand, December. *Nikon F4, 105mm AF f/2.8 Micro-Nikkor lens, Ektachrome 100 Plus.*
 These two pictures of a small, pink geranium flower show how changing the position of the focal point within the frame, as well as the format orientation, affects the dynamics of the picture. Centering a small flower in the frame (above) creates an unimaginative, static composition; placing it off-center (opposite page) causes the eye to roam over the frame long enough to appreciate the distinct leaf shapes.

plane of focus in a ratio of two-thirds behind and one-third in front (for close-ups greater than life-size, however, the ratio is equal on both sides of the plane of focus). The depth of field can be increased not only by stopping down the lens, but also by decreasing the image size. Thus by changing from a standard 50mm lens to a wide-angle lens of 35mm or less (on a 35mm format), more of the scene can be brought into focus.

If you want a rock or clump of flowers in the foreground to be in focus as well as more distant plants, refrain from focusing on the nearest object, since this will be a waste of the potential depth of field. Instead, maximize it by using the hyperfocal distance. Focus on the nearest object and read off the distance, then focus on the farthest object and note this distance. Then, referring to the depth-of-field scales

on the lens, select the aperture, and refocus the lens without looking through it; this will give you the depth of field you require.

There are times, however, when a more successful picture can be achieved if you don't stop the lens down, resulting in a sharply focused foreground subject against a muted, out-of-focus background.

Using a tripod rather than hand-holding the camera aids composition, as you can spend much more time deliberating the most appropriate depth of field for each shot by checking the depth-of-field preview button before releasing the shutter. A tripod will also enhance the depth of field by allowing a slower shutter speed—and hence a smaller aperture—to be used.

Power Points

The position where you elect to place one or more flowers in the frame makes all the difference between producing an eye-catching picture and a mere record shot.

The composition often is improved or made more powerful by placing a flower or flowers off-center so that they lie on one of the four power points—the four points within a rectangle where a pair of equidistant vertical and horizontal lines intersect. If slavishly followed, however, this approach would become boring. It may not always prove practical to compose a picture in this way with the lenses you have at your disposal, and in any case, rules are made to be broken.

Patterns and Designs

The distribution of wildflowers in general is not haphazard, since each kind of plant favors a particular combination of conditions in which it can flourish. These include the habitat, altitude, aspect, soil type, depth of soil, and amount of rainfall. While some flowers grow en masse, forming spectacular single-colored carpets, many grow intermingled with others to create attractive multicolored mosaics.

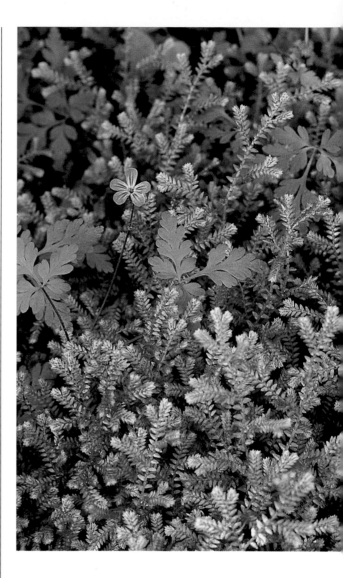

Regular arrangements of plants are not uncommon, following straight or curvaceous lines, notably in narrow bands along the margins of tracks, streambanks, or man-made fields. In such situations, where plants have a linear distribution, they provide the potential for composing flower pictures with powerful diagonal lines. So, too, will flowers of plants growing in narrow cracks of otherwise barren rocks. Many sand dune plants migrate across the dunes

Ramsons or wild garlic *(Allium ursinum)* and ferns in limestone pavement, Malham, Yorkshire, England, June. *Nikon F4, AF 35–70mm f/2.8 Nikkor lens, Ektachrome 100 Plus.*

Naturally sculpted by acid rain and frost action, exposed limestone pavement areas in Yorkshire are a photographer's delight. Strong winds and constant browsing pressure from sheep make the cracks in the rock the sole safe haven for plants. The naturally weathered limestone brings a strong design element to any picture taken in this unique part of England. Metering has to be done directly on the leaves inside the crevice.

by producing a series of runners in straight lines, and their flowers also appear in a linear progression. Sometimes just two or three plants or blooms can be juxtapositioned so that they lie on a diagonal line across the frame.

In the upper reaches of tidal mangrove swamps and salt marshes, seeds become beached as the water recedes. Depending on whether the waterline is straight or curved, the flowers will follow this configuration. Some freshwater plants grow only in a fairly precise depth of water, and you can often find a curvaceous band of color around all or part of a pond margin.

Vines or olive trees planted in a regular pattern give a strong design element to pictures taken of wildflowers blooming beneath them. In Victorian Britain, elaborate floral displays of carpet bedding were commonplace in gardens of country mansions, where plants were laid out in multicolored patterns reminiscent of a Turkish carpet. These highly labor-intensive displays are nowadays virtually confined to municipal parks, where the flowers tend to be replaced by dwarf plants with colored foliage.

Flower photographers usually strive to achieve sharply focused images of some or all of the flowers within the field of view. There are other approaches, however, whereby indistinct images are produced, although these may not always gain universal appeal. Viewed through a soft-focus filter, clumps of flowers become transformed into a creative abstract interpretation. Framing clumps of colored flowers with a long lens and defocusing them will also produce indistinct images that nonetheless may contain a subtle element of design. Instead of letting a persistent wind ruin your day, why not utilize it to create deliberate soft-focus photos? Tall-stemmed flowers work best. Focus the camera and select a slow shutter speed to blur the colored heads as they are blown across the frame. Minimal depth of field is another artistic approach that can be applied to close-ups (pages 8 and 117).

Floral Themes

You may initially be motivated to photograph flowers growing near your home or spectacular displays seen while on location, but once you have become hooked on flower photography, you will want to do more than take random shots. One way to instill a purpose to your flower photography is to think thematically. Once in possession of your first macro lens, it is a perfectly natural instinct to want to rush around taking frame-filling portraits. But is this the most creative way to work? After the initial euphoria of getting in really close has worn off, you begin to appreciate that other lenses can be used to take equally—arguably more—memorable flower pictures.

Plants in Their Habitat

Showing flowers in their habitat is always a challenge, since you cannot fall back on brightly colored petals filling the frame. Thought, therefore, must be given to what information will be conveyed in the final picture, which in turn will influence which lens is most appropriate for achieving the desired end result.

Whenever I want to portray the location, not only do I spend some time walking around to find the best specimen or patch of flowers, but I also consider what single factor will immediately convey the habitat to anyone else who sees the picture. Quite simply, this means water in a wetland, sea and rocks or sand on the shore, sand dunes in a desert, or a snow-capped peak in a mountain region. The traditional way of showing a plant in its habitat is to use a wide-angle lens and shoot at a low angle, with the flowers in the foreground and trees in a forest, rocky cliffs, or a mountain peak rising up behind as a backdrop. For conspicuous clumps and taller flowers, this technique works quite well. In flat wetland sites, a high camera angle—from a bridge or a hill—will show a watery expanse behind an emergent aquatic plant.

It is always worthwhile thinking of variations on these angles. One idea I gained from working in the confined spaces of urban gardens is to get up high and to look down—a bird's-eye view. I find the boarded-in roof rack on my four-wheel-drive invaluable for shooting meadow flowers over hedgerow tops bordering fields or flowers in woodland glades. In this case, a short telephoto lens may be more appropriate than a wide-angle. In places inaccessible to automobiles, a tree can help you gain an elevated viewpoint. Aerial walkways in tropical rainforests provide a totally different perspective within this species-rich habitat.

When working at high altitudes, it is a good idea to keep an ultraviolet-absorbing filter, such as a haze filter, on the camera to

Thrift *(Armeria maritima)* flowering at Land's End, Cornwall, England, May. *Nikon F3, 35mm f/2.8 Nikkor lens, Kodachrome 25.*

Pink clumps of thrift enliven many a rocky European headland in late spring. Even though this picture was taken two decades ago, it still sells well, as the wide-angle view with the sea behind immediately conveys the maritime habitat.

Giant lobelia *(Lobelia deckenii bequaertii)* growing at 10,500 feet on Mount Ruwenzori, Uganda, August. *Nikon F3, 35–70mm f/3.5 Nikkor lens, Kodachrome 25.*

My trip to Ruwenzori, one of several East African mountains with gigantic herbs, arose as a result of a commission from an Italian magazine. Part of the deal was that I should have a porter to carry all my gear, but whenever I wanted my tripod and cameras, he was either a mile ahead or a mile behind me! For years, each giant lobelia exists as a basal leaf rosette, but it eventually gives rise to a spectacular flower spike, which is pollinated by hummingbirds. It is hard to believe this plant is related to the small lobelia used as a bedding plant, but inside each green bract is a small purple flower. Behind the lobelia is a tree heath festooned with epiphytic mosses.

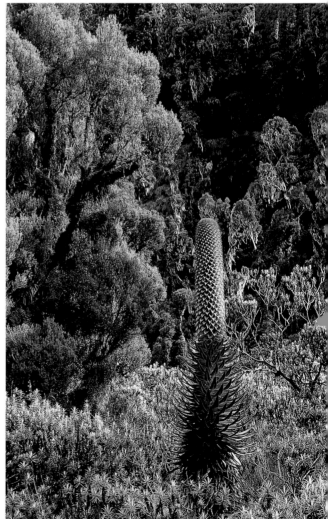

Red bottlebrush *(Kunzea baxteri),* a west Australian shrub, photographed in a California garden, February. *Nikon F4, 105mm AF f/2.8 Micro-Nikkor lens, Ektachrome Lumière 100.*

There are many different kinds of bottlebrushes, related to eucalyptus trees, in Australia. The most conspicuous parts of the flowers are not the petals but the long, brightly colored stamens. This frame-filling shot homes in on the flower to show the pollen-tipped stamens.

counteract the increased ultraviolet radiation, which tends to give photos a bluish cast. This will be more apparent in a landscape than in a close-up.

Life Histories

Any way that you can slow down your picture taking inevitably provides more time to appraise the composition, which should be a recipe for taking better pictures. Making a sequential record of a plant's life history over a period of several weeks involves repeated visits to the same location. Knowledge gained about the direction of light and shadow at particular times of day can be invaluable for planning the best time for later visits.

Time spent studying a flower as it unfurls from a bud, opens out to its full glory, withers, and ultimately develops into a fruit cannot fail to give a better understanding of plant form and function. You don't have to be a botanist to appreciate that translucent petals or hairy leaves appear more dramatic when backlit, or that solid textured surfaces are emphasized by grazing light across them.

Since 1990 I have tutored a week's intensive course on plant photography at the Royal Botanic Gardens, Kew, in London each spring. Before students expose a single frame, they spend most of the first day looking at the structure of flowers under a stereo microscope. Everyone agrees that this makes them much more observant when framing and focusing the camera. Time spent studying floral structure will always pay dividends when it comes to appraising the camera angle and type of lighting.

The evolution of floral shape and color is inextricably linked to the way a flower is pollinated. For example, flowers pollinated by bees and butterflies tend to be conspicuous and brightly colored, and may also have attractive patterned guidelines leading toward the center of the flower, as can be

Deherainia smaragdina, a Mexican plant, taken under glass at Kew Gardens, Surrey, England, April. *Nikon F4, 105mm AF f/2.8 Micro-Nikkor lens, Ektachrome 100S with Nikon SB24 fill flash.*

This is an interesting flower on three counts: It is green in color, it has a fetid smell, and the stamens initially lie bunched around the stigma (left). When ripe, they spring away when touched by a visiting insect (right), thereby aiding pollination.

Swallowtail butterfly feeding on scarlet paintbrush *(Castilleja indivisa)* with blue-bonnets *(Lupinus texensis),* near Austin, Texas, April. *Nikon F4, 105mm AF f/2.8 Micro-Nikkor lens, Ektachrome 100S.*

A macro lens with a focal length of 100 or 200mm is ideal for photographing a larger insect feeding on a flower. I spotted the swallowtail feeding nearby, and by loosening the panning screw on the tripod, I was able to rapidly reframe the shot when it moved on to the next paintbrush flower. The relatively shallow depth of field resulted from the obligatory fast shutter speed (1/250 second), as the butterfly's wings constantly vibrated.

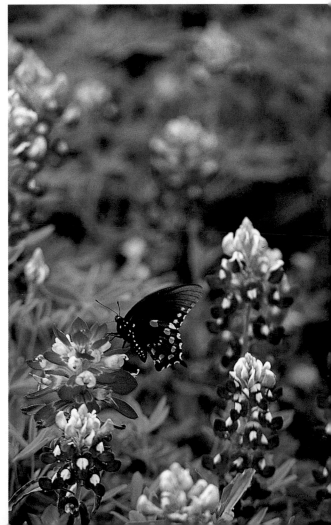

Guelder rose *(Viburnum opulus)* berries with wild clematis *(Clematis vitalba)* fruits in hedgerow, Hampshire, England, October. *Nikon F4, 300mm AF f/4 Nikkor lens with extension tube, Ektachrome Lumière 100.*

I waited for the first frosts to enhance the leaf color before taking this autumnal cameo. It was lit by sun late in the day, and I used a tiny reflector to push some light in underneath the fruiting sprays.

Female flowers of European larch *(Larix decidua),* Surrey, England, February. *Nikon F4, 105mm AF f/2.8 Micro-Nikkor lens, Ektachrome Lumière 100.*

The minute, yet exquisite, rose-shaped female larch flowers are often overlooked, yet they make delightful macro subjects early in the year. They appear just before the fresh green needles break. Using a macro lens, it wasn't difficult to render the grass behind as a simple out-of-focus backdrop.

Poppies *(Papaver rhoeas)* and scentless mayweed *(Tripleurospermum inodorum)* growing on roadside, Surrey, England, June. *Nikon 50–300mm f/4.5 Nikkor lens, Ektachrome Lumière 100.*

In past years, before selective weed killers were widely used on arable land, cornfield wildflowers were a common sight in England. Today, striking color mosaics such as these red poppies and white daisies are virtually confined to disturbed ground beside newly made roads or fieldside margins. With such a versatile zoom, I was able to get many different crops from a single viewpoint.

seen in violas and irises. Many flowers that we see as a single color, such as yellow evening primrose and yellow rock rose, sport ultraviolet light patterns invisible to us but apparent to insect eyes. The purpose of these is to lure insect pollinators, which,

95

Bluebonnets *(Lupinus texensis),* Texas, April. *Fortunately, the radiant blue color of the state flower of Texas is not a problem to reproduce accurately on slide film. The three pictures represent a mini photo essay on bluebonnets. Little detail of individual flowers can be distinguished within a wide-angle shot portraying the sea of blue. At closer range, the spacing between individual blooms becomes discernible, but subtle markings on the white areas of the petals are not apparent until a few plants fill most of the frame. I was particularly attracted to the three spikes growing in a diagonal line.*

Opposite page, top: Nikon F4, 20–35mm AF f/2.8 lens, Ektachrome 100S.

Opposite page, bottom: Nikon F4, 80–200mm AF f/2.8 lens, Ektachrome 100S.

Right: Nikon F4, 105mm AF f/2.8 Micro-Nikkor lens, Ektachrome 100S.

after they feed on nectar or gather pollen from one flower, will cross-pollinate the next one they visit. Flowers pollinated by birds—notably hummingbirds—tend to be red in color, such as hibiscus and scarlet gilia.

Photographs of insect pollinators visiting flowers are always a challenge but make for added interest among any collection of flower pictures. One of the easiest ways to photograph insect visitors is when the first flowers of a species open. With only a limited choice of flowers available, the odds of an insect visiting the one you are focused on are greatly increased. By no means do all flowers produce yellow or orange pollen; it comes in a variety of colors, including white (wine cup) and even dark blue (oriental poppy).

Even dead blooms may inspire works of art. The British photographer John Blakemore recorded the life and death of tulip blooms in a vase over many days. These photos were published in his book *Inscape*. If weathered flowers don't appeal to you,

it's worth checking out the fruits, some of which can be more colorful than the flowers. Brightly colored berries, which tempt birds and mammals to feed (and thereby to help disperse them), inevitably also attract photographers. When photographing shiny fruits, which naturally reflect sun as a highlight, don't double up on the highlights by using a reflector or direct flash. Even on a dull day, it is preferable to use indirect flash either by bouncing it or by using a diffuser (see Part IV). Seeds and fruits that develop

fine, hairy or feathery appendages are prime candidates for backlighting.

Unlike large, showy magnolia and tulip tree flowers, which are pollinated by insects, photographers often overlook wind-pollinated flowers, which include grasses as well as many flowers of trees such as birches, pines, and yews. These can make exciting macro subjects, however. Among the most exquisite of female flowers produced by a conifer are the red larch "roses," which stand erect on the branches. After pollination, they develop into the brown larch cones.

Nature's Palette

Memorable photographs of any subject are the result of many factors gelling together, including luck at being in the right place at the right time and the ability to perceive a picture from the multitude of possible compositions. There is nothing I enjoy more than discovering attractive color combinations of different kinds of wildflowers. These

Heather *(Erica cinerea)* with silver birch *(Betula pendula)* regeneration on burnt heathland, Surrey, England, August. *Hasselblad 500 C/M, 80mm f/2.8 Planar lens, Ektachrome 64.*

After an extensive fire raged through a heathland area near my home during one long, hot summer, I set myself the task of documenting on film the succession of plants that gradually invaded the charred ground. Four years later, silver birches were beginning to regenerate, and heather—the dominant plant of heathlands—had begun to flower, bringing a welcome splash of color to the blackened landscape. I waited for the sky to become overcast so that there would be no harsh shadows, and then chose a square medium format to frame part of the scene, to convey the new life bursting forth among the distorted gorse skeletons.

give much greater scope for creative compositions than a close-up of a single bloom. Gardeners with an artistic eye constantly strive to create plant associations that are harmonious not only in their time of flowering, but also in their color shades and tones.

Initially an artist and a needlewoman, the British garden designer Gertrude Jekyll (1843–1932) turned to designing on a broader canvas—the garden—after she developed acute myopia. She used her artistic eye to skillfully gradate color schemes in the border, and she understood how one color could be used to emphasize another. An example of harmonious plant associations in a British garden can be seen on page 101.

But nature's palette achieves some equally stunning color combinations: red and white (poppies and scentless mayweed in Britain); blue and red (bluebonnets and paintbrush in Texan fields or blue penstemon and scarlet gilia in Wyoming); blue and pink (bluebells and campions in British woodlands or bluebonnets and pink evening primrose in Texas); pink and gray (cistus and lavender in the Mediterranean [page 10] or sticky geranium and sagebrush on Rocky Mountain prairies); or blue and yellow (purple echium and a yellow crucifer in Spain [page 67] or bluebonnets and yellow coreopsis in Texas). I use a medium-length telephoto zoom lens, such as 80–200mm, to fill the frame with these natural bouquets. When working from a vehicle, a small, 20-inch-high stepladder helps me to gain a higher perspective looking down onto these floral harmonies.

Photographing One Kind of Flower

An excellent way of developing your perception is to give yourself a challenge. What better way to do this than to choose one kind of plant—preferably one of reasonable size and abundance—and to photograph it in as many different ways as possible? As well as varying the lens, the viewpoint, and

Southern marsh orchid *(Dactylorhiza* sp.*)* with bird's-foot trefoil *(Lotus corniculatus),* Hampshire, England, July. *Nikon F4, 105mm AF f2.8 Micro-Nikkor lens, Ektachrome Lumière 100.*
 This orchid thrives in damp meadows where tall vegetation is kept in check by livestock. British nature preserves with wild orchids, includng this one, are regularly grazed. Selecting which spike to photograph among thousands was quickly resolved when I spotted this orchid juxtaposed with the yellow trefoil flowers. This picture was one of many stills I took while demonstrating how to photograph flowers for a BBC countryside television program.

the lighting, try also to vary the location. This way, you will come to better appreciate not only the floral structure, but also the surface texture of petals and leaves. It is always profitable to study the structure of a plant before you decide how to light it. For example, plants with shiny leaves will reflect much more light than hairy, matte leaves and so are better lit indirectly. This can be done by shooting on an overcast day, by holding a diffuser between direct sunlight and the plant, by placing a diffuser head over a flash, or by bouncing the flash.

Each of the three images of bluebonnets reproduced on pages 96 and 97 illustrates a different aspect of this plant. Together they provide information about the habitat where the plant grows, the density of the blooms, and the floral structure. Pictures of other plants growing in association with bluebonnets can be seen on pages 33, 38, 80, and 81.

Succession
The downside of flower photography is that all plants have a limited flowering season. A long-term project that can span one or

The Apothecary's rose *(Rosa gallica officinalis)* in a Welsh garden, June. *Hasselblad 500 C/M, 80mm f/2.8 Planar lens, Ektachrome 100 Plus.*

 It was the harmonious blend of colors and shapes of the rose and lavender flowers that appealed to me in this informal planting, which I photographed in sunlight. The Apothecary's rose is one of the oldest historic roses, with cultivation records dating back to the thirteenth century. It was prized for its delightful fragrance as well as for medicinal purposes.

101

more years is to document the succession of flowers that bloom in a specific area, such as a nature preserve, from the first bloom of spring to the last bloom of summer. Such a project provides a purpose for venturing outdoors in all kinds of weather, if only to check out what is about to come into flower. Over the years, I have drawn up my own floral diary in which I record the first date I see a particular plant in bloom. This enables me to check the timing for an average season and, since plants tend to bloom in succession, to predict the timing for an early or late season.

Another long-term project is to record the succession of plants that invade an area after it is burnt, such as the 1988 fires in Yellowstone National Park. I have done just this with a preserve near my home.

Flower Families

Orchids, both wild and cultivated, are arguably the most popular of all flower families, and I know many people who "collect" them on film, which is infinitely preferable to collecting actual specimens. Notching up species within a single family can provide great satisfaction, but the main danger of this approach is that you stick to one technique because you know it is safe. I can guarantee that there is nothing more boring than having to sit through a slide show of a hundred or more temperate terrestrial orchids all positioned centrally in the frame and lit with an uncreative frontal ring flash. I know, because I have been subjected to just such a torturous evening.

When making a photographic collection of related flowers, aim to introduce some variety by using different lenses, lighting, and compositions. One way of expanding the scope of an orchid portfolio is to include epiphytic tropical orchids. These perch on trees, so instead of lying prone on the ground with a macro lens, the technique is to look up with a long lens.

My own passion is for roses—both wild and cultivated. Whether I take close-up portraits of individual blooms or do a study of associated plants growing naturally in the wild or planted in gardens, photographing roses gives me enormous pleasure. For me, their subtle beauty and the ephemeral nature of some species of roses make them even more of a challenge than many tropical orchids. After blooming, many roses produce attractive hips, which are equally worthy of photography.

One advantage of concentrating on a single diverse family of flowering plants is that you could become known for this—although I suspect it would be difficult to earn a good living working within such a narrow field.

Close Encounters

Moderate close-up studies help focus attention on the color, form, and texture of individual flowers. Extreme close-ups can highlight the structure of floral parts and even depict commonplace flowers as extraordinary.

There can be nothing casual about taking close-ups. An acute eye is essential for extracting details from the profusion of shapes. Indeed, it can help to carry a hand lens in your photo vest to see if it is worth the effort of setting up the camera and tripod. Precise framing and focusing are also critical factors in the production of memorable close-ups.

Repetitive pattern pictures succeed or fail by the way they are cropped and the

Backlit *Geranium × magnificum* flower, author's garden. *Nikon F4, 105mm AF f/2.8 Micro-Nikkor lens, Ektachrome 100 Plus.*

I grow flowers and shrubs from many parts of the world in my Surrey garden, so I can photograph the blooms in the best possible light. Knowing that the flowers of this geranium have translucent veined petals, I had a clear vision of the picture I wished to achieve. It was then only a question of waiting for low-angled sunlight late in the day, when they would become exquisitely backlit. To determine the correct exposure, I manually spot-metered a backlit green leaf.

Detail of giant vegetable sheep *(Haastia pulvinaris)*, Nelson Lakes Park, New Zealand, January. *Nikon F3, 105mm f/3.5 Micro-Nikkor lens, Kodachrome 25.*

During a visit to New Zealand, I made a detour and climbed up to 5,500 feet to photograph a curious alpine plant that hugs the rocks. Vegetable sheep, with its rolled, hairy leaves, belongs to the daisy family. The site was windswept, but fortunately the dense growth habit of the plant prevented any movement, making a slow exposure possible.

magnification used. Tightly cropping to exclude all traces of the background color ensures that the eye concentrates on the pattern itself, which can be as simple as a mosaic of mat-forming alpines that hug the ground, the overlapping arrangement of a giant lobelia leaf rosette, or the packing pattern of sunflower seeds. A macro lens is preferable over extension rings here, since it provides continuous increasing magnifications, whereas every time an extension ring is added, the magnification increases by stepped amounts, which can compromise the framing. When taking a landscape photograph, moving the camera a few millimeters to the left or right will not greatly affect the composition, but it can make a world of difference in close-up photography. Having a firm camera support is crucial to the success of all close-ups.

By convention, close-up photography begins at a magnification of one-tenth (X0.1) on the film plane up to life-size (X1.0). The term photomacrographs (not macrophotographs, which means big photographs) is more appropriate for magnifications greater than life-size.

Getting in Close

The easiest (and least expensive) way to take a close-up is by attaching a close-up lens to the front of the camera lens. This is

Kaffir lily *(Clivia miniata)* in a Surrey garden, England, March. *Hasselblad 500 C/M, 80mm f/2.8 Planar lens + 1.0 Proxar (close-up) lens, Ektachrome 100.*

For larger flowers such as this Kaffir lily, a close-up lens is an ideal way of getting in closer to achieve a portrait with more impact. Unlike extension tubes, the close-up lens does not cause any loss of light, an added advantage.

105

comparable to an eyeglass lens used by a far-sighted person to focus on near objects. The power of a close-up lens is given in diopters. A +2 diopter lens magnifies twice as much as a +1 diopter lens. The shorter the focal length of the close-up lens, the greater the magnification. Several close-up lenses are easily carried in a photo vest pocket. Since these lenses do not reduce the amount of light reaching the film plane, no increase in exposure is necessary. Although the magnification can be increased by using two close-up lenses together, this is not recommended, since every piece of glass placed in front of a prime lens will further reduce the quality of the photograph.

The problem of flare is exacerbated when using a close-up lens or filter, since the

Dog rose *(Rosa canina)* buds, Hampshire, England, June. *Nikon F4, 135mm f/3.5 Nikkor lens with extension ring, Ektachrome 100 Plus.*

An extension ring fitted to a short tele-photo lens allowed me to get in close to the breaking buds of a wild rose in a hedgerow. In this photograph, taken late in the day, the backlighting helped to separate the spray from the background while a small reflector helped to fill in the shadows.

Detail of floral parts of hibiscus, Surrey, England, July. *Nikon F4, 105mm AF f/2.8 Micro-Nikkor lens with bellows extension, Ektachrome 100 Plus.*

The advantage of growing plants is that you have the chance to study them over a period of time. I was fascinated by the elaborate structure of the inside of a hibiscus flower, so I decided to use a bellows extension to crop in tight with part of the petals filling the background. A greater-than-life-size magnification on the transparency revealed the individual pollen grains on the multi-headed red stigma above the stamens.

glass surface protrudes beyond the front element of the lens itself. It is therefore wise to remember to replace the lens hood after attaching a close-up lens.

Although a close-up lens is a speedy way of getting in close, it offers limited scope and is suitable only for larger flowers such as lilies, roses, and sunflowers. For greater magnifications of smaller subjects, it is better to use extension rings, a macro lens, or a bellows extension. Both the rings and bellows are fitted between the camera body and the lens. Auto rings are a must. They allow all the automatic functions of the camera to be retained, such as the lens diaphragm remaining open, thus providing maximum illumination for critical focusing right up to the moment the shutter is released. Extension rings are available in a set of variable lengths; together these usually provide 50mm of extension, which gives life-size (X1.0) magnification with a standard 50mm lens but half life-size (X0.5) with a 100mm lens. Extension rings can be used individually or in any combination with almost any lens. Indeed, a short extension ring reduces the minimum focusing range of a long lens.

Since any extension ring increases the lens-to-film distance, it reduces the amount of light reaching the film plane. With cameras having a TTL metering system, this presents no problem, since the light is

Prickly burr *(Acaena magellanica),* South Georgia, December. *Nikon F4, 105mm AF f/2.8 Micro-Nikkor lens, Ektachrome 100 Plus.*

This pair of pictures illustrates how the size of the lens aperture controls the depth of field. Both were taken in overcast light.

Top: With a wide-open aperture (f/2.8), only a single plane is in focus.

Bottom: By stopping down to an aperture of f/16, all four flower heads were brought into focus.

Flame flower *(Tropaeolum speciosum),* Kew Gardens, Surrey, England, August. *Nikon F4, 105mm AF f/2.8 Micro-Nikkor lens, Ektachrome 100S.*

This creeper was growing over an upright conifer. By getting the camera back parallel with the plane in which the flowers were growing, I was able to get them all in focus right across the frame. The red flowers and green leaf mosaic provided a good average tone for using the matrix in-camera metering.

metered directly at the film plane. When using a hand-held light meter, however, you need to compensate for the loss of light. For example, when 25mm of extension is used with a 50mm lens, an extra stop is needed (either open up the lens aperture one stop from f/11 to f/8 or reduce the shutter speed from 1/60 to 1/30 of a second). Using 50mm of extension with a 50mm lens will require two additional stops.

Anyone who is at all serious about taking close-ups will forget about extension rings and opt for a macro lens, which comes complete with its own built-in extension. Macro lenses are available in different sizes, and their price increases with the focal length. The cheapest and most widespread is the 50mm or 55mm macro, followed by the 90mm or 105mm, and the most expensive is the 200mm. Even though I have all three Micro-Nikkor (macro) lenses, I use the 105mm 90 percent of the time. For the same magnification, compared with the 55mm macro, it gives me twice the working distance between the lens and the flower for angling in a reflector. The 200mm macro is ideal for stalking butterflies feeding on flowers, since the working distance is four times that of a 55mm macro lens and double that of a 105mm macro lens.

For magnifications greater than life-size, either insert extension rings between the macro lens and the camera or use a bel-

Broad-leaved glaucous spurge *(Euphorbia myrsinites)*, author's garden, Surrey, England, April.
Nikon F4, 105mm AF f/2.8 Micro-Nikkor lens, Ektachrome 100S.
 Comparison of the pair of spurge pictures (taken at life-size) shows how the shadows caused by direct sunlight striking a highly three-dimensional flower confuse the eye. By using a diffuser or photographing on a dull day, the soft lighting allows the eye to better appreciate the highly elaborate floral structure.
 Top: Direct sunlight. Bottom: With diffuser.

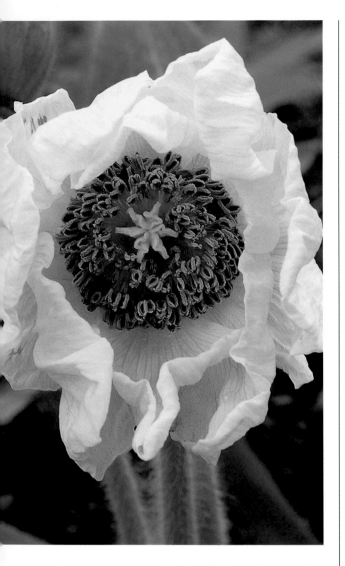

Lampshade poppy *(Meconopsis integrifolia)*, Kew Gardens, Surrey, England, May. Nikon F4, 105mm AF f/2.8 Micro-Nikkor lens, Ektachrome Lumière 100.

The best known of the meconopsis poppies is the Himalayan blue poppy, but yellow and even red meconopsis also exist. Here, the six-part stigma surrounded by the mass of golden stamens is recessed inside the yellow petals. There was no way I could angle light into the heart of the flower with a reflector, so I decided to use fill flash. This was tricky, since I didn't want to burn out the petals. I bracketed the fill flash and found that the best exposure was one and two-thirds stops less than the daylight exposure.

Depth of Field

Depth of field as applied to general flower photography is covered in Part VI, but nowhere is it more important to understand than when taking close-ups. The depth of field—the zone of sharp focus in front of and behind the plane on which the lens is focused—is reduced as the magnification is increased. Therefore, with a close-up, the maximum depth will be achieved only by focusing the camera *not* on the part of the flower nearest the camera, but a short distance behind, so that most—if not all—of the flower will be in focus when the lens is stopped down. The extent of the depth of field for a given magnification and lens aperture can be seen by manually stopping down the lens with the depth-of-field preview button.

lows extension. Made of black fabric, the latter can be extended up to 150mm. Inexpensive bellows units are fitted with a single rack-and-pinion system that is used to vary the amount of extension, whereas better-quality units have a second system that functions like a focusing slide by moving the camera and bellows unit nearer to or farther away from the subject. This is invaluable when taking close-ups where a set magnification is required, such as for a field guide.

An easy way to maximize the depth of field is to place the film plane (the camera back) parallel with the main plane of focus. For an overhead view of a creeping plant, this means maneuvering the camera on a tripod so that the back is horizontal to the ground; for flowers growing on a wall, the camera back needs to be positioned parallel with the wall.

Lighting and Exposure

Many of the techniques described in the lighting section (Part IV) can be applied to close-ups. Indeed, compared with photographing flowers in the landscape, one of the plus points about taking close-ups is that you have much greater control of the lighting over a small area. Reflectors and diffusers are essential aids for taking better close-ups. There are occasions when I use both together, as when photographing a pastel-toned flower flooded by harsh sunlight without a cloud in the sky. By holding a diffuser between the sun and the flower, the light is softened, and then a reflector can be angled in underneath to fill in any recessed areas.

Fill flash is also an invaluable tool for close-up work, although you cannot see the precise effect it will have on the final picture.

When using extension rings, a macro lens, or bellows, it is much easier to use TTL metering instead of a separate hand-held meter. Beware, however, that very pale or very dark flowers will create problems because they reflect much more or much less light than an average tone (see page 44).

In dark locations, such as inside forests, exposures up to 1 second or more may be needed when using a slow-speed film in order to stop down to f/8 or f/11 to get a reasonable depth of field. To eliminate any chance of camera vibration with long exposures, use the mirror lock and a cable

Scarlet paintbrush *(Castilleja indivisa)*, Texas, April. *Nikon F4, 105mm AF f/2.8 Micro-Nikkor lens, Ektachrome 100S.*

A close-up reveals that the brilliant red parts of this flower are, in fact, bracts and not petals. Using the depth-of-field preview button, I selected a fairly large aperture to ensure the background grass appeared out of focus.

release to fire the shutter. For cameras without long exposure times of 1, 2, or 4 seconds, use the B setting and keep the shutter open using a cable release while counting "one thousand," "two thousand," and so on for each second. If you practice doing this while looking at a wall clock with a second hand, it is easy to count seconds with sufficient accuracy. If your camera doesn't have a B setting, use the T shutter setting, which requires an initial pressure on the release to open the shutter and a second to close it.

When I first started photographing over two decades ago, the effective film speed was reduced when exposures greater than 1 second were used. This was known as reciprocity failure. When making long exposures, we had to allow not only for this, but also for a shift in the color balance. Fortunately, the chemistry of today's color emulsions has improved to such an

Nodding sunflower *(Helianthella quinquenervis)*, Grand Teton National Park, Wyoming, July. *Nikon F4, 105mm AF f/2.8 Micro-Nikkor lens, Ektachrome 100.*

When focusing on a single bloom among many, such as this sunflower, throwing the background flowers out of focus echoes the petal color and also serves to convey the relative abundance of the flowers. This picture was taken shortly after the sun rose high enough to reach the flowers growing on Signal Mountain.

Maple *(Acer sp.)* flowers bursting from winter buds in spring, Surrey, England, May. *Nikon F4, 300mm AF f/4 Nikkor lens with extension tube, Fuji Velvia.*

By using a long lens with a small extension tube, I was able to isolate the small, lime green maple flowers against a clear blue sky. This is a case where a tripod is essential not only to prevent camera shake, but also to ensure precise framing.

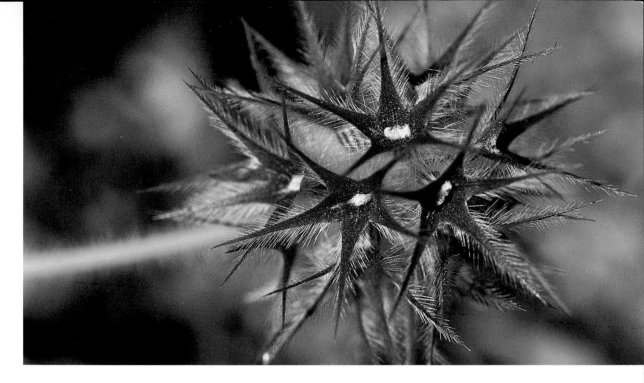

Star clover *(Trifolium stellatum),* southern Spain, April. *Nikon F4, 105mm AF f/2.8 Micro-Nikkor lens, Ektachrome Lumière 100.*

Without using any artificial props, a dramatic difference can be made to the clarity of a close-up that is found with a distracting background simply by casting a shadow on the background but not the subject. This causes the sunlit flower to stand out from the shadow area behind.

Top: As found.

Bottom: With shadow cast behind plant.

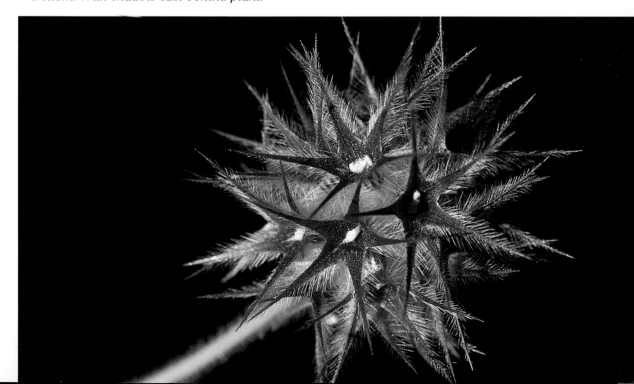

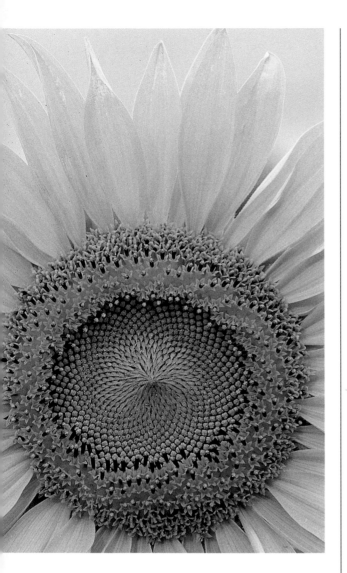

Detail of sunflower (Helianthus annuus), Argentina, January. Nikon F4, 105mm f/2.8 Micro-Nikkor lens, Ektachrome 100 Plus.

An enforced wait in Buenos Aires while our ship bound for Antarctica was being refitted gave us several days to explore the surrounding countryside. On one trip we passed fields of sunflowers. As well as taking a wide shot, I chose to crop in tight to highlight the spiral arrangement of the central disk florets.

Differential focus is a useful technique for separating flowers from their background. Here, the flower appears sharply focused against a muted, out-of-focus background. This will happen automatically when the background is a long way from the flower; otherwise, it may be necessary to open up the lens to isolate a flower from a confusing background. Partly out-of-focus objects such as twigs or grass stems can spoil a close-up. If they are dead and lying on the ground unattached, careful "gardening" is in order. Live woody stems and branches can be tied back carefully beyond the field of view and replaced after photography.

Always check the final effect using the depth-of-field preview button. While it is still depressed, open up and close down the aperture ring to see which f-stop gives the best effect.

A long-focus lens used with an extension tube can be invaluable for achieving a soft-focus background for larger flowers, but if photographing a waterside plant, beware of distracting highlights from sunspots on the water. They will appear as polygonal areas (the shape of the iris diaphragm) that become smaller and more distinct as the lens is stopped down. Use the depth-of-field preview to determine which aperture gives the least objective highlights.

One way of leading the eye toward the subject is to photograph it surrounded by other flowers that appear as soft, out-of-

extent that it is possible to expose Ektachrome 100S and SW films for up to 10 seconds without any additional exposure or filtration required.

Selective Focus

Once the fundamentals of depth of field have been grasped, it is possible not only to become highly selective about where you focus, but also to decide how much or how little depth of field you want for each close-up.

focus images. This works only when all the flowers are the same shade or the out-of-focus ones are a more subdued tone than the subject. If the converse is true, so that out-of-focus red poppies frame sharply focused white daisies, the eye will constantly be lured back to the powerful red—even though the flowers are not sharply defined.

Backgrounds

It is all too easy to be bowled over by a stunning close-up possibility and give insufficient time and thought to careful consideration of the background. Yet lack of attention to such detail can ruin a close-up. While brightly colored blooms will tend to stand out from their immediate surroundings, it is always worth spending a little time scanning the background to check that there are no distracting shapes or colors. Sometimes a slight change of camera angle or opening up the aperture is all that is needed to eliminate the problem.

Green leaves can make a harmonious background to many flowers, but they need to be sufficiently blurred so as not to detract from the flower itself. When focusing on a single flower among many, such as a sunflower, repeating the petal color with out-of-focus blooms can make an effective composition as well as serve to convey the relative abundance of the flowers. A low camera angle can be used to isolate flowers of trees or taller blooms such as sunflowers against an uncluttered sky. Beware of out-of-

focus clouds and vapor trails, however, which can lure the eye away from foreground flowers.

Utilizing light and shadow is a good technique for shorter plants or plants growing in forests. Early or late in the day, I often come across a plant naturally spotlit by sun so that it stands out from its background in shadow. Where sunlight beams down through the canopy onto a forest floor, a plant may be lit

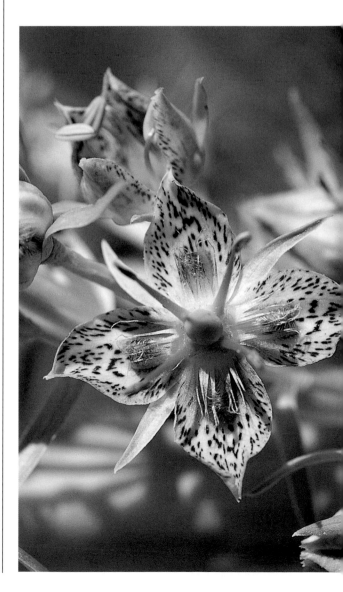

Green gentian *(Frasera speciosa)*, Togwotee Pass, Wyoming, July. *Nikon F4, 105mm AF f/2.8 Micro-Nikkor lens, Ektachrome Lumière 100.*

The intricate pattern and color of a green gentian flower can be appreciated only when seen in close-up. I had to wait quite a while for the wind to drop, as the tall spike was very prone to movement.

only momentarily, so you have to work fast to take advantage of the natural spotlighting. If the moment is lost, it is always possible to use flash to spotlight a flower from the side. In any habitat, using flash to backlight a flower is always an effective way of making it stand out from its surroundings.

When both the flower and the background are equally lit by direct sun, a background shadow can be cast behind the flower by judicious positioning of a com-

panion or a photo pack. Comparison of the two star clover pictures on page 113 shows just how effective this technique can be for eliminating a confusing background.

You may come across situations where flowers in the shade are standing out from a brightly lit background (see page 24), although the exposure difference may be too great for transparency film to handle.

Floral Shapes and Patterns

One of the delights of getting in close to plants is that their floral structure can be better appreciated. No one focusing the camera to take a close-up at half life-size or greater can fail to marvel at details that had previously gone unnoticed. For example, at a glance, members of the daisy family simply appear to have a ring of outer petals encircling a central disk. A close-up viewpoint reveals that the central disk is made up of florets in a spiral arrangement. Other examples of spiral forms in the plant world include tendrils of climbers as well as the arrangement of magnolia and water lily petals.

When tall, spiked flowers such as foxgloves, delphiniums, or green gentians are photographed from a distance so that the entire spike is included, the diminutive size of the individual flowers makes it difficult, if not impossible, to appreciate their structure. If the frame is filled with a single flower, however, the floral structure becomes apparent. From a distance, a green gentian appears as a not overly attractive pale green spike, whereas a single flower taken at life-

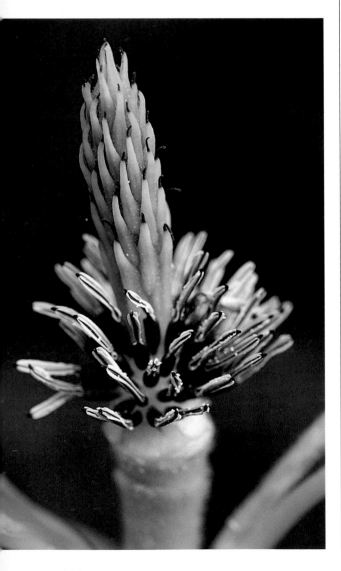

Floral parts of magnolia, Surrey, England, April. *Nikon F4, 105mm AF f/2.8 Micro-Nikkor lens, Ektachrome 100S.*

On large, single flowers such as magnolia, there are pictures still worth taking after the petals have fallen. This close-up study shows the way the stamens persist around the central stigmatic column after the petals have fallen.

size magnification reveals a four-part symmetry and exquisite purple markings.

Plants belonging to the parsley family, such as hemlock and Queen Anne's lace (see page 2), have many flowers grouped together to form an umbel. These provide plenty of scope for close-up designs at various magnifications. Long after the flowers have withered, the persistent dried seed heads also make attractive close-up patterns. On many a midwinter morning I have sought hogweed seed heads decorated magically with frost. Additional sparkle can be added by holding a flash so that the light grazes across the surface.

A tight crop into the heart of a large magnolia, poppy, peony, or cactus flower, so

Detail of carnation flower, studio. *Nikon F4, 105mm AF f/2.8 Micro-Nikkor lens with a 4X close-up lens, Ektachrome Lumière 100.*

Using a magnification of 1.5X on the film and a wide-open aperture to ensure minimal depth of field, I found an abstract picture within the center of a carnation flower. Compare this with the tulip flower (page 8), which was taken in a similar way.

that most of the petals are excluded, focuses attention on the essential reproductive parts—the stamens, which produce the pollen, and the stigma, which receives it. The structures of many flowers have evolved to ensure elaborate cross-pollina-

117

tion mechanisms. When fireweed flowers first open, the pollen-laden stamens protrude so that a visiting bee picks up some of the pollen. As the flowers age, the stamens wither and the stigmas protrude, ready to be dusted with pollen when a pollen-loaded bee pays a visit.

Floral Abstractions

An artistic approach to floral close-ups is to abstract their shape and color by using minimal focus. Contrary to what you might suppose, this is by no means an easy option; you still have to compose the picture by evaluating shapes and colors that merge with one another. To achieve minimal depth and decreased sharpness, you need to use parameters opposite those for increasing the depth of field: Shoot with the lens wide open (the faster the better), use a longer focal length in preference to a short one, increase the magnification with some extension, and forget about using flash.

I usually work at magnifications greater than life-size by using a 105mm macro lens and adding either an extension tube or a close-up lens. Diffuse available light provides soft, muted colors, which I favor for abstractions. This technique can totally transform familiar flowers into beautiful abstract images.

The two advantages of using minimal focus are that the open aperture will give you a fast enough shutter speed to hand-hold the camera, and you don't need a depth-of-field preview.

Given a floriferous meadow at the peak of perfection, the scope for trying out many approaches to taking close-ups is limitless. As you become absorbed in creating different ways of portraying the blooms, your sole limitations will be fading light at the end of the day or a lack of film. I know—I have been there!

Reaping Rewards

Virtually everyone begins by taking photographs of flowers purely for pleasure, but as more time and money are invested in this hobby, the desire to recoup at least some of the expenses begins to grow. There are several ways to earn money from photography. The suggestions outlined in this chapter are by no means exhaustive, but for me they have all been good earners.

Any of these can be combined with a full- or part-time job. Indeed, if you decide to take the next step and go freelance, it is essential to have a regular source of income, because initially the rewards from photography will be erratic. Without a regular source of income, you may have to skimp on film and travel, which can hamper your photography career.

Lecturing

When I took the plunge to go freelance, the bulk of my income came from giving illustrated lectures for adult education departments at three different universities, four nights a week for six months of the year. Was I thankful I had qualified as a zoologist and worked as a marine biologist!

I shall also forever be grateful that I spent some of my childhood in New Zealand, where all children from age five upward are encouraged to say a few words in front of the class. For some people, standing up and speaking in front of an audience may seem impossibly daunting, but you can always start by giving a slide show to friends and relatives, followed maybe by a talk to a local natural history society. If you know your subject, are enthusiastic, and have reasonably good slides, it shouldn't be too much of an ordeal. Possible lecture topics could include an account of a local nature preserve or a description of a rich botanical site.

Be sure to edit your slides so that you don't have to make excuses about their quality. Remember, less can be more. It is far better to show fewer slides and leave the audience wanting to see more than to have them yawning in the aisles. Many years ago, I made it a rule never to show more than eighty, and often I show less. Whenever I prepare a new lecture, I lay a hundred or more slides on a large light box, arrange them into a sequence, and gradually edit them down.

Writing Articles

If you enjoy writing, the easiest way to gain an income from photography is by producing illustrated articles. Many magazines are published on a weekly or monthly basis, and the potential market for the freelancer who can deliver a text and photo package is huge. Before submitting any material, study each magazine carefully and write for edito-

Using a light box to arrange a sequence for a lecture entitled "Why Photograph Plants?"

rial guidelines. If these are not available, assiduous study of two or three issues will pay dividends. It is essential that you know not only the preferred article length and the ratio of text to pictures, but also the type of reader at whom the editorial team is aiming. Without this background information, even the most carefully researched article may fail to attract the editor's eye; with it, a rejection slip will be much less likely.

For as long as I can remember, I have been an inveterate list maker, itemizing my daily or weekly priorities. Whenever I get an idea for an article, be it on location, in a train, on an airplane, on a boat, waiting at an airport, or even in bed, I jot it down. Several years ago I realized how much down

time I spent each year hanging around airports, sitting on airplanes, and traveling in boats to remote locations. I vowed never to travel anywhere without several large, spiral-bound notebooks in which I can write articles and draft book outlines. Indeed, I wrote five chapters of this book while at sea traveling to the Falklands en route for South Georgia and back again, and the rest in China waiting to photograph pandas in the snow. Why don't I carry a laptop computer? Quite simply, because I think so much faster than I can input, I can forget the gist of a line of thought, and also because I have a brilliant lady who speedily transforms my scribbles into immaculate copy the day I return to England.

Potential outlets for articles with photos of wildflowers include not only photo magazines, but also regional, travel, natural history, and even gardening titles. If you have

an idea for an article, it is worth contacting the editor or features editor to check that the subject has not been covered recently, rather than waste time working on a topic that has already been featured. (The editors' names are usually on the magazine's masthead page inside; otherwise, call to get their names.)

I would advise against producing a complete unsolicited article. Instead, make a neat presentation on a single page using a word processor or computer, including the proposed title (the editor may change this), a sentence or two about the main angle, and an outline of the contents broken down beneath a series of subheads. Don't bombard the editor with too much material. If you have already been published elsewhere, send some tear sheets or color copies of the article. Rather than original transparencies, send either duplicates or color laser copies, being sure to state that they have been made from color transparencies. Finally, enclose a self-addressed, stamped envelope, or international postal coupons if you are submitting to an overseas publication.

To send the complete feature abroad, use either an accelerated air postal service that ensures a signature on delivery or an air courier such as Federal Express. Although

Copy of an article published in the British magazine Amateur Photographer, *outlining how to take one kind of flower—in this case a poppy—and devise varied ways to photograph it.*

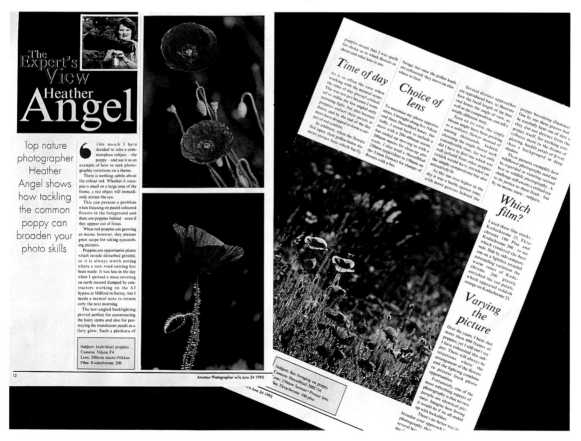

Barbados pride *(Caesalpina pulcherrima)* in Barbados, April. *Nikon F3, 105mm f/3.5 Micro-Nikkor lens, Kodachrome 25.*

A low camera angle allowed me to fill the background with blue sky, providing not only a perfect foil for the vibrant flowers but also an area of negative space at the top for over-printing a magazine name.

have a much larger budget, with a full-time picture editor injecting more creativity into the way the photos are used. If the policy is to have picture-led articles with a full-page or double-page spread opener, the type of picture selected will be quite different from those for a quarter-page or smaller sized reproduction. Pictures composed with an area of negative space at the top, such as blue sky, a sand dune, a mountain in shadow, or out-of-focus green grassland, allow room for the title of the article when used inside or the masthead of the magazine if reproduced on the front cover. Many magazine covers also require space for overprinting the topics covered by the lead stories, as well as the now obligatory bar code. It is also worth composing horizontal pictures with an area of sky, water, or sand at one side so they can be run as a double-page spread with space for overprinting introductory copy. A recent trend is to scatter cutouts of images among the text. If cutouts are specified, select relatively simple flower pictures without any branches, leaves, or grasses overlapping in front of them. In this case, background shapes and colors are immaterial, since they will be eliminated from the floral cutout.

Shooting Stock

Another way to earn money is to shoot stock pictures. Stock photography enables you to select the subjects and the way you light and compose them, unlike commissioned photography, whereby you have to work to an art director's brief. At first, you

more expensive, I prefer the latter; not only is delivery faster, but also the package is tracked all the way and a signature is obtained on delivery.

The circulation of the magazine is a prime factor influencing the number of pictures and the manner in which they are used. A regional, low-circulation magazine is more likely to use small pictures that are secondary to the text; a high-circulation national or international publication will

may find your personal taste is not every-one's cup of tea, and the pictures that appeal to you may not sell well as stock images. But a glance through calendars, magazines, and books will give you an idea of what kinds of images sell: punchy color, wide scenes with foreground emphasis, and soft-focus atmospheric pictures, as well as patterns and designs. Multicolored floral studies of different kinds of flowers growing together work well on calendars as well as greetings cards, whereas pictures illustrat-ing biological life processes such as pollina-tion, seed dispersal, or mineral deficiency are most likely to be used in textbooks or gardening magazines.

My best-selling plant picture proves that you don't have to spend a lot to achieve a high earner: It was taken in my own back-yard! The travel time was nil, and the expense merely the cost of the film. I have no doubt that the frog resting on the lily pad beside the water lily flower was a great bonus.

Close-up of a cinquefoil *(Potentilla* sp.*)* flower showing five-part symmetry, Surrey, England, May. *Nikon F4, 105mm AF f/2.8 Micro-Nikkor lens, Ektachrome 100S.*

An overhead view of a flat flower head without any overlapping petals or leaves is ideal for a cutout on a white page.

You can either sell stock pictures yourself or place them with a photo agency or pic-ture library, which will take 40 to 50 percent commission. Over the years, agencies have often approached me to represent my work, but I have always resisted them. Because I write so extensively, I have always wanted to keep complete control over all my pic-tures, so right from the start I decided to market them myself and set up my own photo library. In the early days, I not only took the pictures but also answered the phone and researched want lists. Gradually I was able to afford part-time help, and now I have several employees who run the

library whether I am back at base or not. While many picture sales now arise as a result of people seeing images in my books or articles, I still have to invest in regular mailings to clients. Initially, these were modest cards with a few color images; now I have a catalog and photo CDs.

Having run my photo library for more than two decades, I cannot imagine operating any other way. It works well for me because I enjoy the business side and like selling, but in order to make a success you have to be pretty dedicated, making sure to keep the deadlines that are constantly being set by clients. When I am not photographing, I am editing pictures, researching picture requests, thinking about new projects, or writing copy.

The difference between taking pictures to illustrate your own articles and shooting for stock is that a stock photo has to stand on its own. It therefore needs to be sufficiently arresting to catch the eye of the editor at a photo agency and to stand out from the other submissions on a client's light box.

The criteria outlined above for cover or double-page spread pictures for magazines

Bumblebee foraging on pickerelweed *(Pontederia cordata)*, Surrey, England, July. *Nikon F4, 105mm AF f/2.8 Micro-Nikkor lens, Kodachrome 200.*

An example of a picture illustrating insect pollination, which can be used in a wildlife or a gardening magazine as well as a textbook.

Frog *(Rana temporaria)* resting on lily pad, Surrey, England, June. *Nikon F4, 80–200mm AF f/2.8 Nikkor lens, Kodachrome 200.*

One of my best-selling pictures, which appeals to adults and children alike. The presence of the lily flower added not only color but also a strong design element to the picture.

are equally applicable here and for books as well. For this reason, when photographing large, conspicuous flowers, such as a protea or a rhododendron, or massed flowers, it is worth composing both horizontal and vertical shots. The cost of a few extra frames is negligible, yet they will ensure you don't miss a sale by not having the preferred format. The narrow vertical cover photo on this book is unusual. To be sure I had a shot I could live with and that would gain approval from both editorial and sales departments, I shot six possible covers, abandoning many that would have clashed with the vibrant yellow cover that runs through the series.

For calendars, check out the topics and types of pictures favored by browsing through the new lines each autumn. Note whether the format for each calendar is horizontal or vertical and whether it uses pictures of wildflowers in the landscape, close-ups, or garden flowers. Even so, you should write for guidelines telling you when to submit, the maximum number of images, and whether to send originals or duplicates.

Self-Publishing

The advantage of placing stock pictures with most agencies is that it won't cost you anything, although some of the larger agencies now charge photographers a fee for each picture reproduced in their catalog, which is usually deducted from the repro fees. However, some photographers prefer to market their own work as cards, calendars, or even books. In each case, money must be invested up front before any profit is seen. But since money has already been spent on camera equipment and film, not to mention travel, investing in some art paper and the cost of some prints can be insignificant by comparison.

Handmade cards often sell well at craft fairs—and are a way of testing out which images are most popular. Nonetheless, it

Left: Double herbaceous borders in a private Hampshire garden, England, July. *Hasselblad 500 C/M, 150mm f/4 Sonnar lens, Ektachrome 64.*

This quintessential English garden scene is always a popular calendar picture and it has also been reproduced for a jigsaw puzzle in Japan.

Right: Roses, blossoms, and water lilies are always popular subjects for greetings cards. These three examples were not shot specifically for reproduction on cards but were among several submitted to a card publisher on a speculative basis.

may be worth questioning whether time spent producing handmade cards could be better spent researching new locations, captioning pictures, or indeed, shooting new pictures.

I use my lectures as means to sell commercially produced cards (some I publish myself; others I buy at trade from publishers that use my pictures) as well as my photo books. Often my earnings from these sales exceed my lecture fee.

Self-publishing a calendar is a higher risk since, unlike cards or books, it has a sell-by date. Again, I buy calendars of my pictures at trade to sell when I lecture.

Book publishing is a major investment and should preferably not be undertaken without gaining some sponsorship. Only one of my forty-four books have I financed. The hardest aspect I found was not the writing, selection of pictures, or marking up the color proofs, all of which I had done for other books, but the distribution of the final product. It does no good to have a worthy product if you cannot get it out to potential buyers.

Kodak was prepared to stage a major traveling exhibition of my garden pictures, if it could be linked to a book. Time was short,

and I couldn't find any publisher that would guarantee a publication date five months later, so I decided to finance the publication myself. I took out a bank loan and printed ten thousand copies of *A Camera in the Garden,* which were sold via garden centers, camera clubs, photo stores, and bookshops, as well as linked to articles with special readers' offers. By investing considerable time, I did sell all the copies and make quite a good profit, but I am dubious it was a particularly cost-effective exercise.

To date, I have restricted myself to the how-to approach for all my photo books. Some, like this one, consist of a series of chapters with continuous running text; several others are designed so that each double-page spread covers a complete topic.

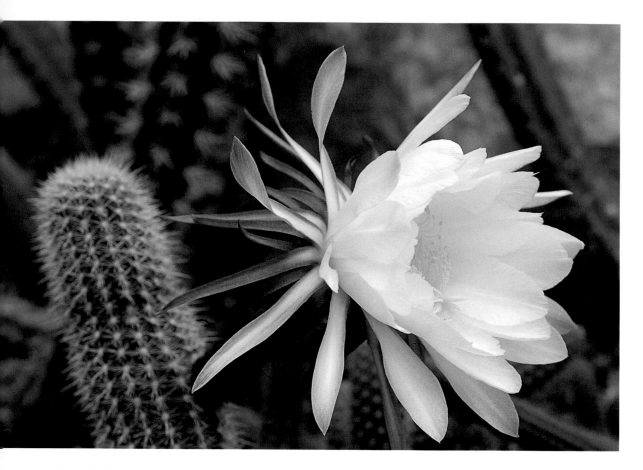

A night-flowering cactus *(Echinopsis aff. strigosa)* from west Argentina, under glass at Kew Gardens, Surrey, England, May. *Nikon F4, 200mm f/3.5 Micro-Nikkor lens, Ektachrome 100S.*
 During a late evening photographic session with my students at Kew Gardens, I noticed the large swollen bud on this cactus. The following morning we made a beeline for the glasshouse. By lunchtime the flower had closed, but I had my first pictures of this intriguing, short-lived flower.

Both approaches have their pros and cons. As a photographer, I am eager to see photographs reproduced as large as possible; as an author, I must have enough space to include all the editorial points I want to cover in the text. Regardless of the design, I begin by drafting the chapter breakdown with subheads. As I start to write and take additional pictures, I constantly make minor modifications, but the main skeleton remains largely unchanged.

Now I am embarking on a long-term photo art book, which will take several years to complete. It is giving me infinite pleasure and ultimately I hope will also prove to be a wise investment of my time. To whatever level you take your photography, the financial rewards you gain should be secondary to your enjoyment of taking and seeing pictures; otherwise there can be little point in continuing along this particular road.

128

RESOURCES

Equipment Sources

Bogen Photo Corporation
565 East Crescent Avenue
Ramsey, NJ 07446-0506, USA
Tel: (201) 818-9500
Fax: (201) 818-9177
 Bogen and Gitzo tripods and also heads.

Cameramac
55 Hodge Bower
Ironbridge, Telford TF8 7QE, England
Tel/Fax: +44 (0)1952 433271
 Custom-made waterproof covers for camera complete with telephoto lens.

Kirk Enterprises
4370 East US Hwy. 20
Angola, IN 46703, USA
Tel: (219) 665-3670
Fax: (219) 665-9433
 Quick-release plates for all major cameras and their long lenses, Low Pod and flash brackets.

Lastolite Limited
Unit 8, Vulcan Court
Hermitage Industrial Estate
Coalville, Leicestershire, LE67 3FW, England
Tel: +44 (0)1530 813381
Fax: +44 (0)1530 830408
 Lastolite reflectors and diffusers.

Photoflex Inc.
333 Encinal Street
Santa Cruz, CA 95060, USA
Tel: (408) 454-9100
Fax: (408) 454-9600
 Diffusers, reflectors and flash modifiers.

Saunders Inc.
21 Jet View Drive
Rochester, NY 14624, USA
Tel: (716) 328-7800
Fax: (716) 328-5078
 Many photo accessories, including Out-Pack® and Photo Backpack; Domke® camera and lens bags and protective wraps; Stroboframe® flash brackets. Distributes Benbo® tripods.

Solargraphics Inc.
P.O. Box 7091P
Berkeley, CA 94707, USA
Tel: (510) 525-1776
 Sun-sensitive paper for making blueprints.

F.J. Westcott Co.
1447 Summit Street
Toledo, OH 43604, USA
Tel: (419) 243-7311
Fax: (419) 243-8401
 A wide range of lighting accessories, including Apollo, Illuminator reflectors.

Resources and Wildflower Hotlines

National Wildflower Research Center
4801 La Crosse Boulevard
Austin, TX 78739, USA
Tel: (512) 292-4200
Five hundred different species of wildflowers bloom on this 42-acre site during the period mid-March to mid-November.

Photo Traveler Publications
P.O. Box 39912
Los Angeles, CA 90039, USA
Internet: http://phototravel.com
Publishes *Photo Traveler,* a bimonthly information resource of photo opportunities (largely USA locations).

California

Antelope Valley Poppy Reserve Visitor Center (805) 724-1180

Anza-Borrego Desert State Park (619) 767-4684

The Living Desert (619) 340-0435

Southern California Wildflower Hotline (818) 768-3533
Operates from March through May.

Colorado

Crested Butte
(970) 349-2571
The wildflower capital of Colorado. Celebrates its Wildflower Festival around the second week of July.

Texas

National Wildflower Research Center
(512) 832-4059 (option 4)

Selected Reading and Reference Books

Angel, Heather. *Photographing the Natural World.* New York: Sterling Inc., 1994.
A how-to book with tips and hints for photographing plants and animals.

Angel, Heather. *Outdoor Photography: 101 Tips and Hints.* Rochester: Silver Pixel Press, 1997.
Solutions—many inexpensive—to solving problems encountered when photographing outdoors.

Crawford, William. *The Keepers of Light.* New York: Morgan & Morgan, 1979.
A history and working guide to early photographic processes.

Ewing, William A. *Flora Photographica.* London: Thames and Hudson, 1991.
More than 200 images have been assembled in this celebration of flower photography from 1835 to the present time.

Leigh, Carol. *61 California Wildflower Locations.* Palm Springs: Picture This, 1996.
What a brilliant conception! An easy-to-read typeface with clear maps of each location, plus space for your own field notes, make this book a must for anyone wanting to photograph California wildflowers. But what else would you expect when it was compiled by a photographer!
Available direct from: Picture This, P.O. Box 2448, Palm Springs, CA 92263, USA.

If you want to identify the flowers you photograph, a wildflower field guide of local flora is essential. There are so many guides available, however, I have listed below only a handful covering major regions. My best advice is to browse through a shop within a park or a nature preserve before you leave the area. Failing this, try to make time to visit a bookshop with a good nature section in the relevant region or country.

Clark, Lewis J. *Wildflowers of the Pacific Northwest from Alaska to Northern California*. Ed. by John G. S. Trelawny. Seattle: University of Washington Press, 1976.

Craighead, John J., Frank C. Craighead, Jr., and Ray J. Davis. *A Field Guide to Rocky Mountain Wildflowers*. Boston: Houghton Mifflin, 1991.
 (Covers northern Arizona and New Mexico to British Columbia.)

Guennel, G. K. *Guide to Colorado Wildflowers: Vol. I, Plains and Foothills*. Englewood: Westcliffe Publishers, Inc., 1995.

Guennel, G. K. *Guide to Colorado Wildflowers: Vol. II, Mountains*. Englewood: Westcliffe Publishers, Inc., 1995.

Hitchcock, C. Leo, and A. Cronquist. *Flora of the Pacific Northwest*. Seattle: University of Washington Press, 1976.

Lötschert, Wilhelm, and Gerhard Beese. *Collins Guide to Tropical Plants*. London: Collins, 1981.

Niehaus, Theodore F., and Charles L. Ripper. *A Field Guide to Pacific States Wildflowers*. Boston: Houghton Mifflin, 1976.
 (Covers Washington, Oregon, California, and adjacent areas.)

Niehaus, Theodore F., Charles L. Ripper, and Virginia Savage. *A Field Guide to Southwest and Texas Wildflowers*. Boston: Houghton Mifflin, 1984.

Peterson, Roger Tory, and Margaret McKenny. *A Field Guide to Wildflowers of Northeastern and North-central North America*. Boston: Houghton Mifflin, 1996.

Polunin, Oleg. *Flowers of Europe*. London: Oxford University Press, 1969.

Polunin, Oleg. *Flowers of South-West Europe*. London: Oxford University Press, 1973.

Polunin, Oleg. *Flowers of Greece and the Balkans*. London: Oxford University Press, 1980.

Polunin, Oleg, and Adam Stainton. *Flowers of the Himalaya*. London: Oxford University Press, 1984.